ALAN RANGER

The "Einheits-Diesel"
WW2 German Trucks

Published in Poland in 2018
by STRATUS sp.j.
Po. Box 123,
27-600 Sandomierz 1, Poland
e-mail: office@wydawnictwostratus.pl

as

MMPBooks,
e-mail: office@mmpbooks.biz
© Alan Ranger
© 2018 MMPBooks
© Wydawnictwo Stratus sp.j.
mmpbooks.biz

All rights reserved. Apart from any fair dealing for the purpose of private study, research, criticism or review, as permitted under the Copyright, Design and Patents Act, 1988, no part of this publication may be reproduced, stored in a retrieval system, or transmitted in any form or by any means, electronic, electrical, chemical, mechanical, optical, photocopying, recording or otherwise, without prior written permission. All enquiries should be addressed to the publisher.

ISBN
978-83-65281-83-8

Editor in chief
Roger Wallsgrove

Editorial Team
Bartłomiej Belcarz
Robert Pęczkowski
Artur Juszczak

Cover
Dariusz Grzywacz

Book layout
Dariusz Grzywacz

All photos author's collection

DTP
Stratus sp.j.

Printed by
**Drukarnia Diecezjalna,
ul. Żeromskiego 4,
27-600 Sandomierz
www.wds.pl
marketing@wds.pl**

PRINTED IN POLAND

In this series of books I have no intention of trying to add to what is a fairly well documented history of these vehicles in texts elsewhere, most notably *"Einheits-Diesel"* Wehrmacht Special No 4017 By Henry Hoppe, whose book was published in 2011, and other books since. Here I hope to give an impression through original photographs, taken both during and before the war, of vehicles as seen through the lens of the normal German soldier, not the professional PK cameramen who's well posed shots are well known and have been published over and over again. As such they have been seen by most interested parties by now already, but the images taken by individual soldiers show a more personal view of the vehicles the soldiers both lived with and worked on, the views that interested the common soldier not the professional propagandist.

For the most part these photographs have been in private collections and have only recently come on to the market. Most images we have used here were taken from prints made on old German Agfa paper stock and the majority of these original prints are no more than 25mm by 45mm in size. Whilst we have used the best quality photos from my collection, occasionally due to the interesting or the rare nature of the subject matter a photo of a lesser quality has been included.

The Einheits-Diesel

With Germany's loss of the First World War and the implementation of the Treaty of Versailles by the victorious allies, the German Army's size in numbers was strictly limited and many types of vehicles were denied them. However the General staff could see that any modern army would need to be highly mobile in any future war. In order to achieve this aim they would have to be largely a mechanized force, they also understood the benefits of standardisation such as a unified parts train, lower cost and faster delivery times. Many factors combined to restrict the implementation of the General Staff's wishes, such as the deep post war financial depression which befell Germany and the major strain this put on the small military budget which was available from the Government coffers. With Germany being a democracy following the end of WWI, the request for a standard design to be taken on by Germany's small vehicle manufacturing base was not met with any enthusiasm. As no one single company had the capacity to manufacture the required number of trucks, there would have to be a collaboration between manufactures. This would require many cross company agreements, but as each individual company, of course considered their designs to be the best and wished also to be the main partner in any cross company venture, no realistic standardisation agreement was possible. The high command was forced to order militarized versions of various companies' standard commercial vehicle offerings, with many of the military requirements simply being ignored. As orders were placed on a best bid basis, many different companies won various contracts so the end result for the Germany Army was a motor pool that was made up from various manufactures' vehicles of different types and designs with a complicat-

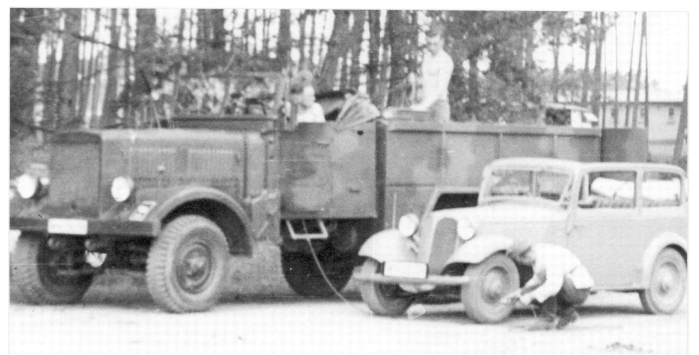

This standard Kfz. 77 *Einheits-Diesel* (Field engineering body type) is seen in its barracks in Munster, Germany during the summer of 1938. Its pre-war factory applied three colour camouflage pattern is clearly in evidence, making it an early production vehicle as later vehicles were painted in the new uniform Panzer Grey paint scheme. Note the engineering truck is using its onboard air compressor to give the BMW saloon parked next to it a helping hand to inflate its left-hand front tyre.

ed and inefficient parts train, hardly the unified approach that was wished for. In the 1.5 ton class requirement the Army had received trucks from Bussing NAG (type G 31), from Margirus the type M 206 and from Mercedes-Benz the type G3 A. All similar in size and power output but without a single interchangeable part between them, only the tyres matched in size but even they came from several different manufactures.

In 1933 with the new Nazi party dictatorship taking control of the German government, all the previous concerns over finance and contract negotiation between various companies came to an abrupt end. With the formation of *Heereswaffenamt* in 1934 (Army Ordnance Office) the German High command now had the power to force Germany's vehicle manufactures into partnerships which would embrace the military's requirements for a unified specification as well as embracing the military requirements of any future vehicle design. Technical limits of the time were the only major block on any finalized design type. To this end the *Einheitsbüro* (Office for Standardisation), with representation from both vehicle manufacturers and the military, was established. The *Einheitsbüro* began to develop specifications for vehicles based on a standardised design (*Einheitstypen*) with the intention that these new designs would replace the older vehicles of various manufacturers' designs. One such standardisation decision was to increase the 1.5 ton off-road truck specifications load weight to 2.5 tons, so as to remove one more type from the manufacturing schedule. This new specification called for permanent all wheel drive, which was to be powered by a designed for purpose new diesel engine. All the manufacturers that were to take part in the contract would produce a vehicle of exactly the same design, with all parts to be interchangeable. The manufacturers to be involved with the production of this new vehicle were Bussing NAG, Daimler-Benz, Faun, Hansa-Lloyd (the light truck division of Borgward), Henschel, Krupp, MAN, Magirus and Vomag. The wooden-bodied vehicles were supplied by many other coachwork companies, again to standard designs. The new diesel engine, designated the HWA 526 D, was manufactured in Nuremberg at a MAN Plant. MAN were thus entrusted to be the design authority for the engine, with the support of designers from both Henschel and Klockner-Humboldt-Deutz.

The brand new *Einheits-Diesel* was first displayed to the public at the Berlin Motor Show of 1936. Indeed the pre-production run was completed before the end of that year and tested in a limited trial, the first production vehicles being produced in 1937. The production of the *Einheits-Diesel* was nonstop until late November 1940. Actual production records for the *Einheits-Diesel* are no longer available and only partial records exist. A report found in the Freiburg Archives states the following:

Chassis Number	Production No	Manufacturer
110001 – 113195	3,195	Bussing Nag
120001 – 120540	540	Daimler-Benz
130001 – 130542	542	Faun
140001 – 142024	2,024	Vomag
150001 – 150242	242	Henschel
160001 – 160557	557	Krupp
170001 – 170704	704	Magirus
180001 – 181295	1,295	MAN
190001 – 192149	2,149	Borgward

This report thus establishes the production total of the *Einheits-Diesel* at 11,248, however this report was only referencing production for the German Army. It is known that *Einheits-Diesel*s were also ordered and supplied to the Navy (*Kriegsmarine*) and Air Force (*Luftwaffe*) in small numbers, as well as civilian customers such as the German Post Office (*Reichspost*), German Railways (*Reichbahn*) and some Municipal Councils for use as snowploughs etc. The *Einheits-Diesel* was also exported to a number of nations. No records of these exports survive, but photographic evidence shows them in service with the Bulgarian, Hungarian and Romanian armed forces. Many of the vehicles supplied to German Civilian organisations were later commandeered for military use, which also adds to the confusion as to the total production run numbers, but it is safe to say the total was higher than 12,000.

Although the *Einheits-Diesel* was intended to replace the myriad of different truck types in the German Military's motor pool it, in the end it only added one more to the number as production was never enough to supply the ever growing need. All trucks were kept in service until they were either destroyed, lost or became beyond viable repair.

The *Einheits-Diesel* was produced in a number of versions, and indeed field modified to serve in a number of other roles as well. The following is a list of authorized production variations:

Based on the Standard truck variant, a truck with a steel rear load bed with fixed steel sides and a set of steel doors in the rear of the cargo bed. The cab was open topped and even the windshield could be folded down if required. The truck came equipped with a canvas tilt for the rear cargo bed and another for the cab, complete with canvas window panels which slotted into the door frames.

Fernsprech Kraftwagen Kfz. 77	Radio Truck
Schneeppflug Type K	Snowplough
Munitions Kraftwagen	Ammunition Truck
Pionier Kraftwagen	Field Engineering Truck
Feldfernkabel Kraftwagen	Field Cable Truck
Feldkuchen Kraftwagen	Field Kitchen
Betriebsstoff Kraftwagen	Fuel Truck
Mannschafts Transportwagen	Personnel Carrier Truck

Based on the standard truck as above but with the rear steel cargo bed sidewalls having an extra door in each side at the cab end of the cargo bed, also a redesigned mudguard arrangement over the rear wheels.

Meßstellen Kraftwagen Kfz. 63	Artillery Ranging Truck
Geräte Kraftwagen Kfz. 63	Equipment Truck
Berge und Abschlepp Kraftwagen	Recovery Truck

Based on an *Einheits-Diesel* chassis but with a fully enclosed timber coach-built body and cab (a closed box body).

Fernsprechbetriebs Kraftwagen Kfz. 61	Radio Truck
Fernschreib Kraftwagen Kfz. 61	Teletype Truck
Verstärkerkraftwagen Kfz. 61	Telephone Cable Amplifier Truck
Kabelmesskraftwagen Kfz. 61	Telephone Cable Testing Truck
Funkbetriebs Kraftwagen Kfz. 61	Radio Operations Truck
Funkpfeil Kraftwagen Kfz. 61	Radio Direction Finder Truck
Funkkraftwagen Kfz. 62	Meteorological Truck
Druckerei Kraftwagen Kfz. 62	Printing Truck
Schallaufnahme Kraftwagen Kfz. 62	Sound Ranging Flak Artillery Truck
Schallauswertungs Kraftwagen Kfz. 62	Sound Analysis Truck Heavy Artillery
Lichtauswertungs Kraftwagen Kfz. 62	Sound Analysis Truck Light Artillery
Vermessungsauswerte Kraftwagen Kfz. 62	Ranging Analysis Truck
Stabsauswerte Kraftwagen Kfz. 62	Staff Officer Command Truck
Funkmast Kraftwagen Kfz. 68	Antenna Mast Truck
Leichter Funkkraftwagen Kfz. 302	Light Command Radio Truck

Based on the *Einheits-Diesel* chassis with a fully enclosed timber coach-built body and cab as above, but with a special body with a central trough for a 30 metre collapsible radio mast to fit into, recognized by a protective shroud above the cab to protect the end of the aerial whilst collapsed and stowed away in transport mode.

Funkmast Kraftwagen (30 m) Kfz. 301 (30 Metre Radio Mast Truck)

Common field modifications were mostly to the standard truck type. The most common of all was for one of the various towed field kitchen types to be loaded in the rear cargo bed and then fixed there, often with stowage added for food items and cooking supplies in the front of the cargo bed. Another common conversion was the addition of improvised lifting equipment to produce a recovery vehicle. Even improvised flak trucks have been seen, with the Italian 37mm gun or 20mm Flak28 mounted in the rear cargo bed.

As the *Einheits-Diesel* was only one of many types of truck in its weight class and the *Wehrmacht* did not keep separate records of its use or allocation to units, discovering the service history of the type is difficult. However due the relatively high number of vehicles produced for its time and surviving photographical evidence, the *Einheits-Diesel* was issued to many different units. Armoured units were issued the lion's share due to their need for a supply truck with off-road capabilities, to accompany them as they manoeuvred over the battlefield. Most other mobile units received a number of *Einheits-Diesel*s as well. It is very rare to find a photograph of a unit equipped in its entirety with the *Einheits-Diesel*s. They appear to have been allocated on a limited basis to most units, however upon the invasion of Russia most of the surviving *Einheits-Diesel*s in the motor pool seem to have been transferred to that theatre of operations. Following the winter of 1941 most seem to have been lost. The high number of *Ein-

*heits-Diesel*s lost is due to a number of reasons, however most common reasons were the lack of trained experienced drivers, and lack of regular maintenance. This was not an issue in peace time. The fact that, as one of the few vehicles equipped with an off-road capability, the *Einheits-Diesel* was often used as a recovery vehicle in the field to tow other trucks caused its own problems. With its own high unloaded weight of 1.5 tons the vehicle was not equipped with the power to undertake such tasks and suffered accordingly. With the retreat in the spring of 1942 many vehicles were lost as recovery and repair facilities were over-run and captured by the enemy. Thus the *Einheits-Diesel*s in for repair were lost for good. A few *Einheits-Diesel*s soldiered on for the rest of the war but mostly in second line units, where they were not needed to cover huge distances and also less likely to be overloaded as they were at the front. Their place at the front was taken by the new breed of 4 wheel drive trucks, such as the Opel, MAN, Krupp and Ford types coming into mass production at that time.

Contemporary comments on the *Einheits-Diesel* in service by the soldiers who used them are rare, but in its pre-war service and participation in the war's early campaigns in the Low Countries and France, the *Einheits-Diesel* seems to have performed very well. It was considered a much valued vehicle by whatever unit it served with. However as time passed by, it gained a reputation as a vehicle which required a lot of maintenance. With its high unloaded weight of 1.5 tons over its rated loaded weight of 2.5 tons, its load carrying ability was just not up to the standard of later types. By the end of the war, the very few vehicles that survived were considered obsolete and unworthy of any further repair, and as no spares had been produced since 1939 spares were in very short supply. Broken down *Einheits-Diesel*s often had to be left behind in any movement.

In conclusion the *Einheits-Diesel* was at the time of introduction a very good design with an excellent design philosophy behind it. However by the end of the war it was totally out-classed by other off-road design types, most notably by those produced in the USA. Whilst it had a production run of approximately 12,000, the later US types had production runs of over 80,000.

It was indeed a very advanced design for its time, hampered in its production numbers by the state of German industry between the wars and then with the pace of design innovation brought about by the war. It was totally surpassed by the war's end. It does, however remain a fine example of a purpose-designed military vehicle and deserves a far higher profile than it currently enjoys, in the eyes of both vehicle historians and the military modeller alike.

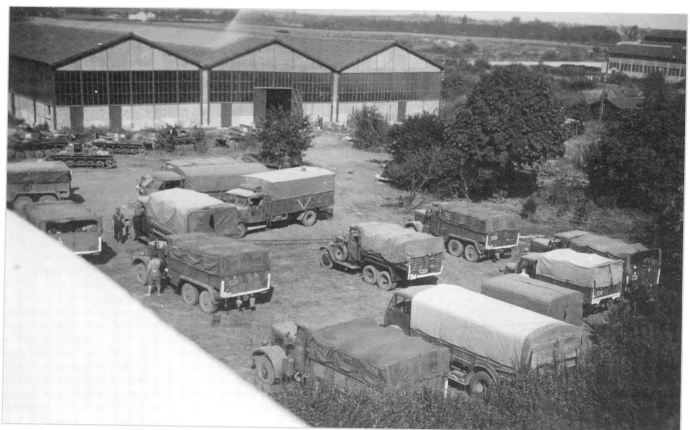

Here we have an interesting shot of a motor pool belonging to the 3rd Panzer Division, parked up in an industrial complex on the outskirts of the French town of Lille, in May/June of 1940. Amongst the many trucks that can be seen are a number of Einheits Diesels, but as can be discovered here even in this early war photo the mix of types of truck assigned to one unit is staggering. The armoured vehicles that are also present in this photo include two Panzer I Ausf B command tanks and a Panzer II Ausf C.

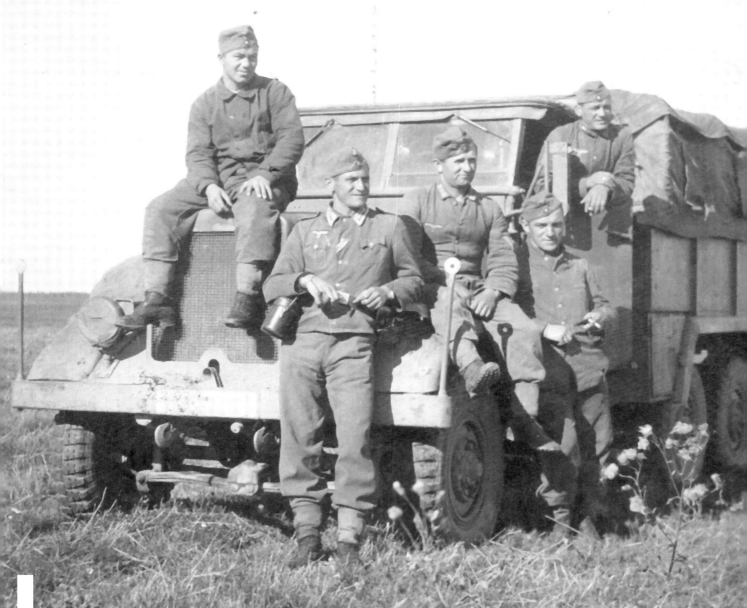

This is a fine example of an *Einheits-Diesel* standard truck, type Kfz. 77 *Pionier Kraftwagen* Field Engineering Truck with its proud crew posing in front of the vehicle.

STANDARD TRUCK VERSIONS

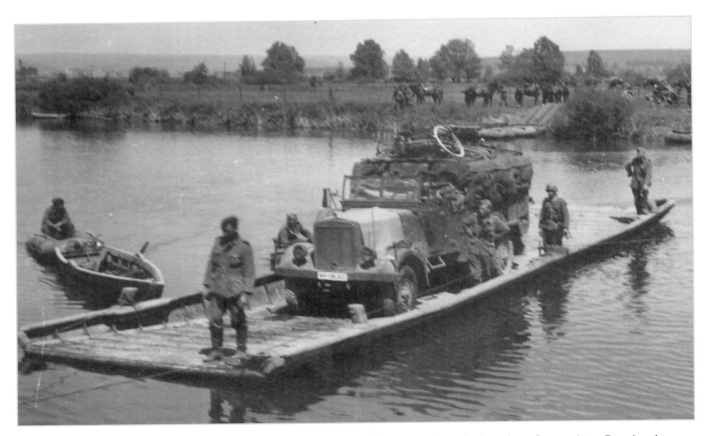

Above: Local ferries are being used to cross this tributary of the River Bug during the advance into Russian in 1942. Of interest is the flag attached across the engine cover and the extra stowage thrown on top of the rear tilt that is unsecured, so will no doubt only be there during the crossing. Note the wooden planks that have been slid under the truck's axles, this is to prevent the truck rocking from side to side on its suspension and making the load unstable, thus sinking the ferry.

Below: Seen here is a fine example of an *Einheits-Diesel Gerate Kraftwagen* Kfz. 63 (Equipment Truck). Note the extra door at the front of the rear cargo bed, the curved shape of the rear mudguard and also the coil of field-telephone wire loaded in the rear.

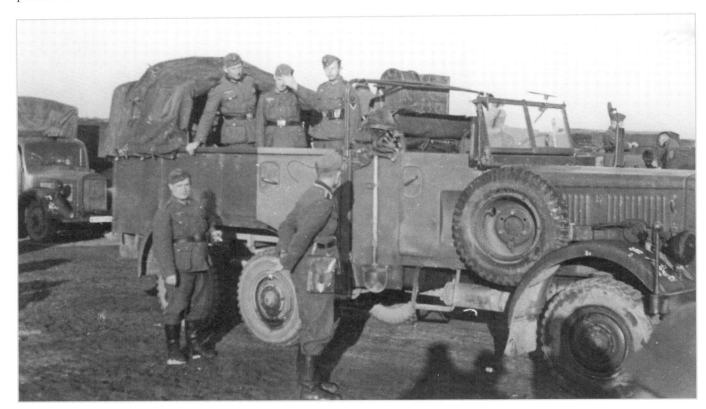

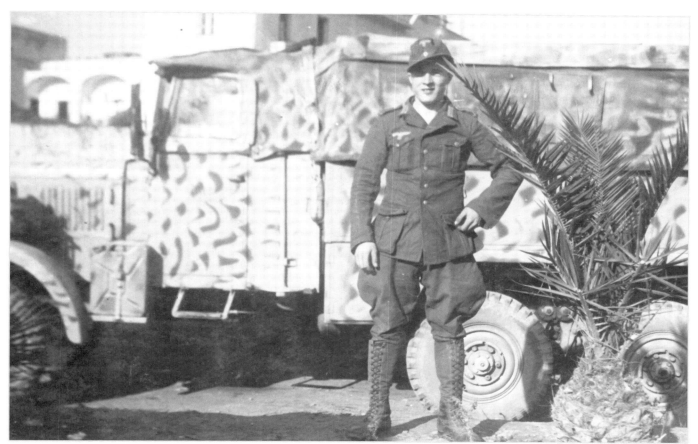

Above: At the very start of Germany's participation in the North African campaign we find here a newly-arrived standard *Einheits-Diesel*. Whilst shipped in its as manufactured Panzer Grey paint scheme, it has received a very quickly applied theatre camouflage scheme by the application of a healthy squiggle pattern of "borrowed" Italian sand paint. Of note here is the proud driver with his new pair of dust boots prominently featured in the photo. However he is yet to be issued desert clothing and is still in his field-grey uniform.

Right: A standard *Einheits-Diesel* drives through the streets of Metz, a town under French control following the end of World War One but recently returned to the German state. The Alsace-Lorraine region became Reichland (territory of the empire) and common property of the German state again in 1940 and been re-occupied by the Germans in 1935. This photo dates from the autumn of 1938.

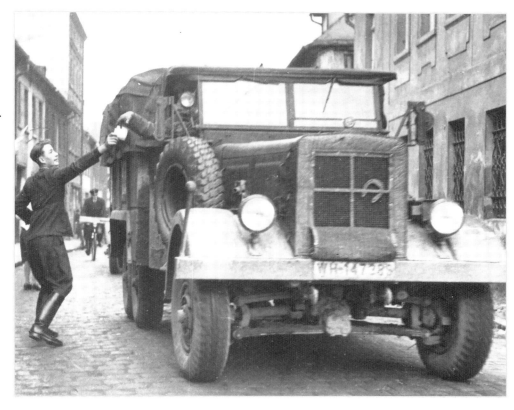

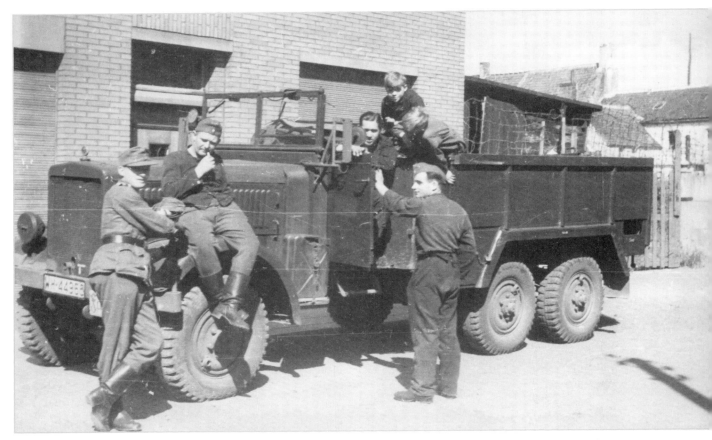

Above: Another standard *Einheits-Diesel*, but this time in a back street of Vienna sometime after the Austrian Anschluss, March 1938. Note the civilian family sitting in the truck – it is most likely that the crew of this truck have been billeted close by and are getting to know the neighbours. (The notation on the rear of the photo reads "my Austrian family").

Below: This unhappy standard *Einheits-Diesel* has been in a bit of an accident and has had its field-applied hard top smashed. The fabrication of timber hard tops for the *Einheits-Diesel* was not uncommon, an indication that a long-serving crew attached to one vehicle in peacetime was allowed to modify their vehicle within reason to serve a particular purpose. An improvised hard top was no doubt preferred to a canvas tilt in many ways.

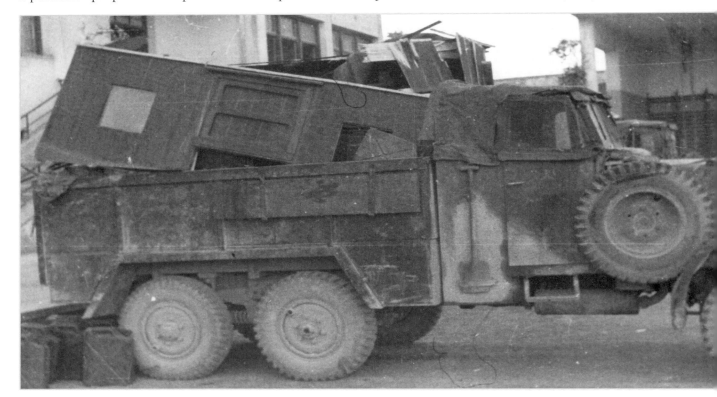

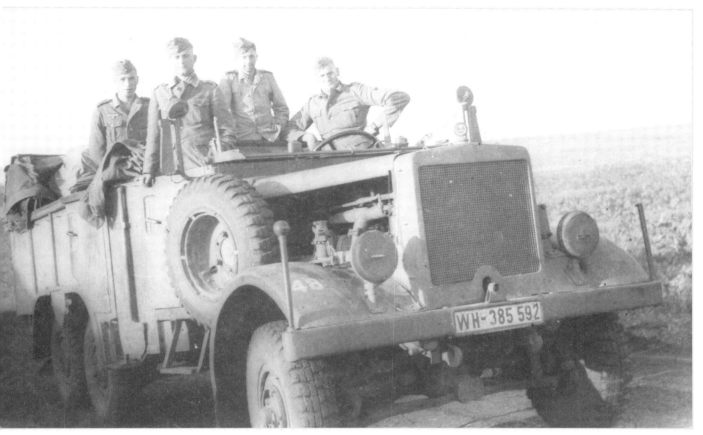

Above: The crew of this *Einheits-Diesel* Kfz. 63 are seen posing in their vehicle in a rear area during the advance into Russia in the summer of 1941. Note, probably due to the number of times that it had to be removed for maintenance, the louvred side panel of the engine cover has not been replaced and the engine is clearly visible, a nice touch to recreate in any model of the subject.

Below: A good profile shot of an *Einheits-Diesel* Kfz. 77 Ammunition Truck. Note the open rear door and the top section of the permanently mounted ammunition racks in the rear cargo bed, also a nice view of the partially rolled back canvas tilt.

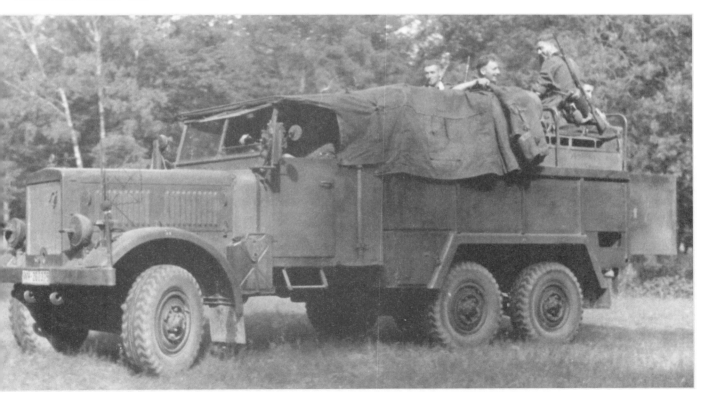

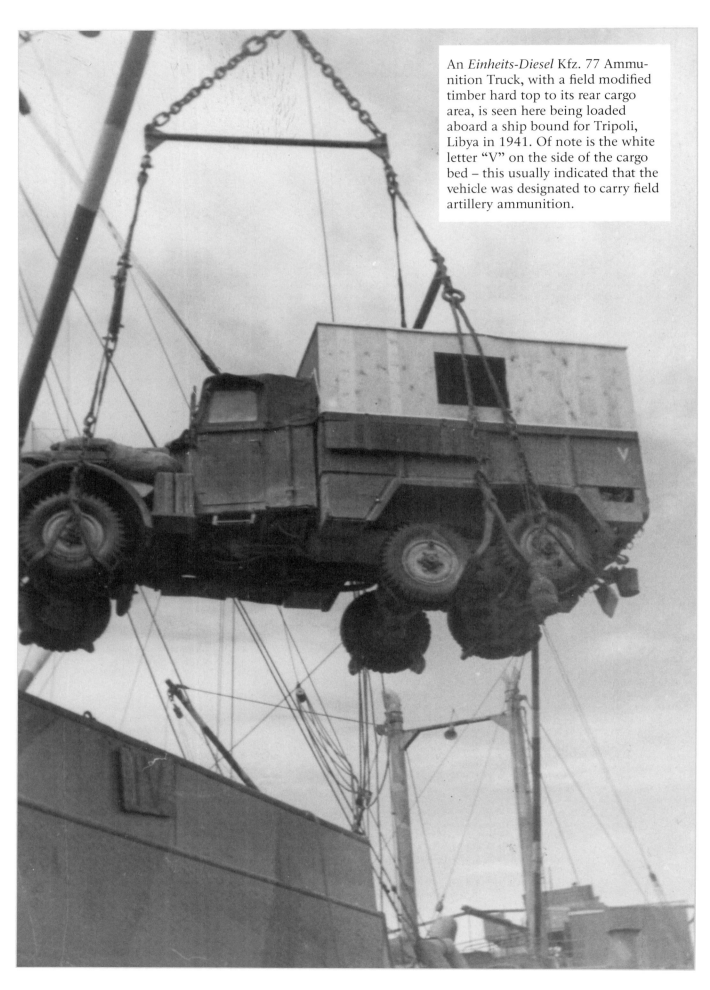

An *Einheits-Diesel* Kfz. 77 Ammunition Truck, with a field modified timber hard top to its rear cargo area, is seen here being loaded aboard a ship bound for Tripoli, Libya in 1941. Of note is the white letter "V" on the side of the cargo bed – this usually indicated that the vehicle was designated to carry field artillery ammunition.

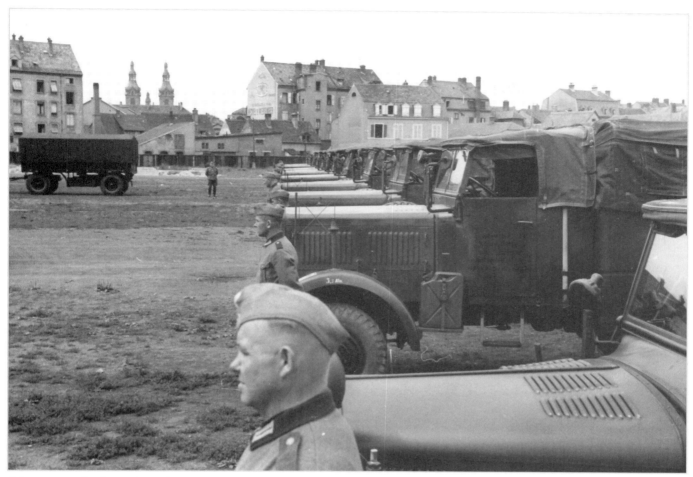

Above: A vehicle park in the German town of Cottbus, close to the Polish border, only days before the German invasion. Of note is that this appears to be one of the very few units equipped exclusively with the *Einheits-Diesel*, although the E-3 standard German trailer clearly in view suggests the presence elsewhere of larger trucks, as an E-3 would prove a challenge to be towed by an *Einheits-Diesel*. It happened when needs must, but the truck would suffer for it. The vehicle in the foreground is for officer transport, it's an Kfz. 15 heavy passenger car.
Below: This 10.5cm howitzer type le.FH 18 was probably not towed here by the *Einheits-Diesel* in the background, but it is more likely that the truck is delivering ammunition to the gun position before a barrage commences. Note the crew taking this time out to relax, also of interest is the flag draped over the truck engine compartment to aid in identification from the air. The advance into France was so rapid that sometimes the advance elements were way ahead of their anticipated position, resulting in misidentification by marauding Stuka units.

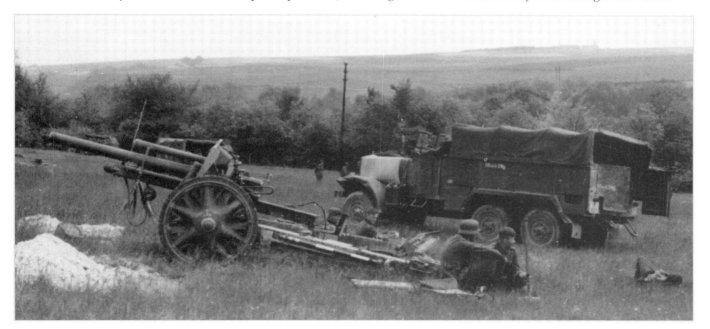

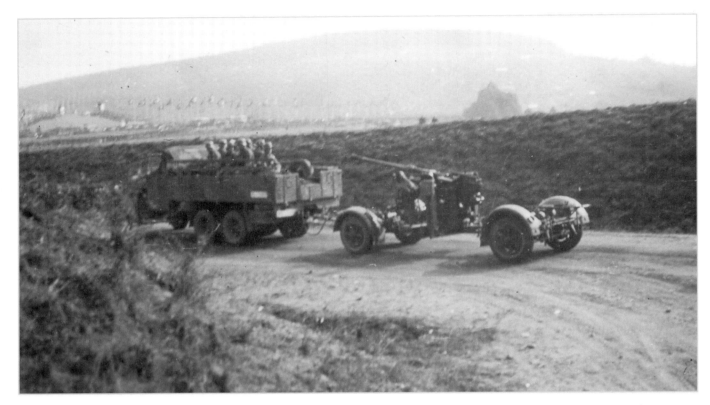

Above: Here we have the more uncommon timber rear cargo bedded variant of the *Einheits-Diesel*, seen here towing a 37mm *Flak* 18 on its Sd. Anh. 202 bogie set. Also of interest here is what looks to be an event going on in the background – note the multitude of flagpoles in evidence.
Below: Parked under some shade, this *Einheits-Diesel* in Greece during the summer of 1942 is in a rather used condition. Of note is the lack of the top part of the engine compartment cover and the battered look of the top of the radiator cover.

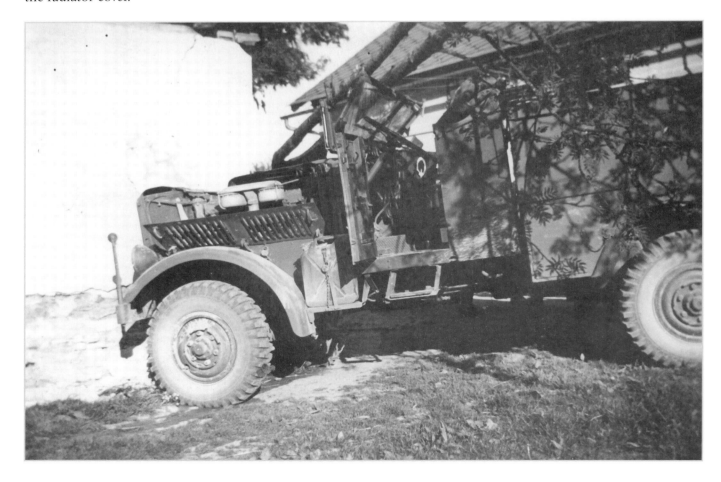

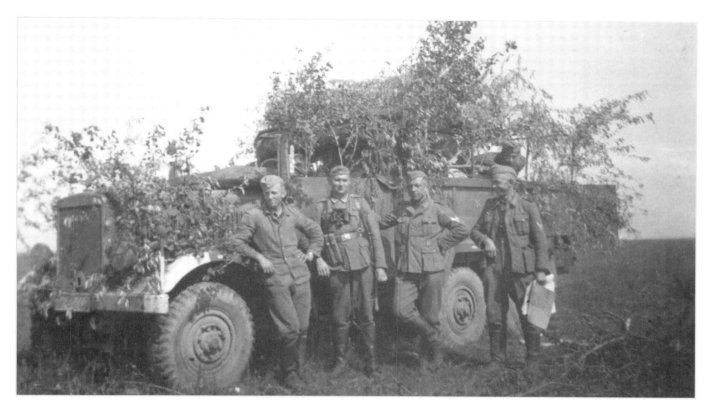

Above: A very good quality photograph of the crew of a standard Kfz. 77 *Einheits-Diesel*. Of particular interest is the amount of foliage being used to prevent identification from the air. How things have changed – earlier in the war recognition flags were the order of the day, yet at the time of this photo (April 1944) the need to hide from enemy aircraft was paramount.

Below: This photo is a fine illustration of the end game for the *Einheits-Diesel*. Here we see one towing a trailer clearly too big for it down a Dutch road in 1944, a time when the few remaining vehicles of the type had been assigned to rear areas and second line duties. Spares were hard to come by and reliability over any distance was uncertain. Note the customized rear tilt and the trailer of non German military design, also the beaten up general appearance of the whole truck.

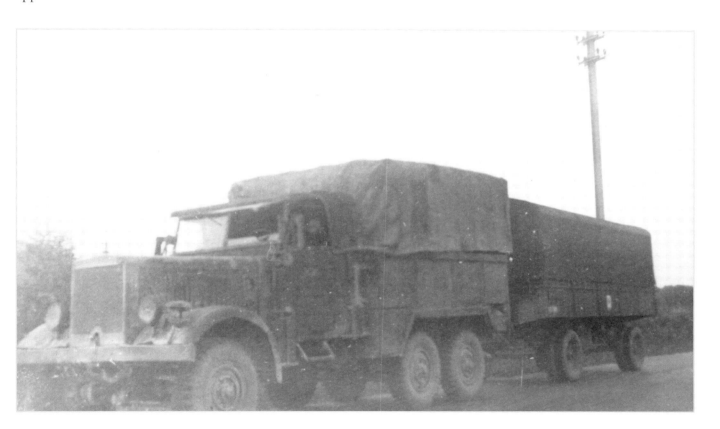

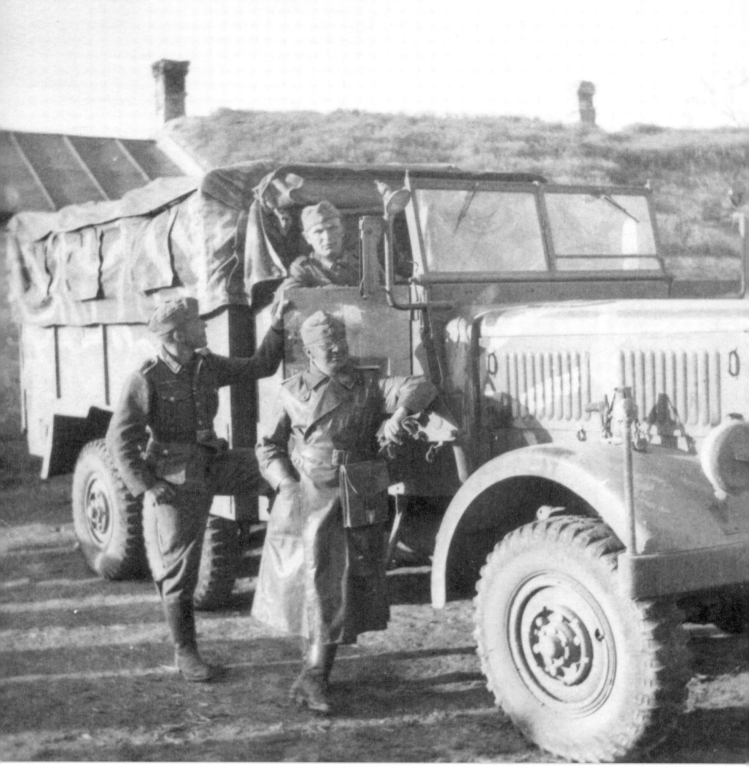

We find this standard *Einheits-Diesel* in central Russia in the autumn of 1941 with a very loose and crudely applied camouflage of sand brown strips over the original Panzer Grey. It could be dirty white paint, but I think it's not.

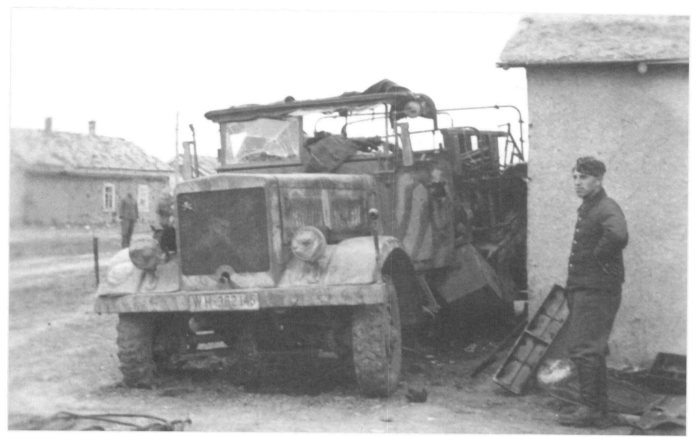

Above: This standard *Einheits-Diesel*, seen in central Russia on 24th May 1943, is in poor condition and looks as if it is being used as a spares donor vehicle for other trucks. Note the flat tire on the front right-hand side, the badly damaged rear cargo bed sides and the cast off tow rope on the ground in front of the vehicle. Also of interest is the rough field-applied camouflage of Dark Yellow stripes over the original Panzer Grey.

Below: An interesting photo showing a train of flatbed cars loaded with a Panzer Grenadier Unit's vehicles and equipment, that include both standard *Einheits-Diesel*s and Kfz. 15 heavy passenger cars. The train is seen here leaving the main rail-yard of Calais, France, following the postponement of Operation "Sea lion", the proposed invasion of England in the autumn of 1940.

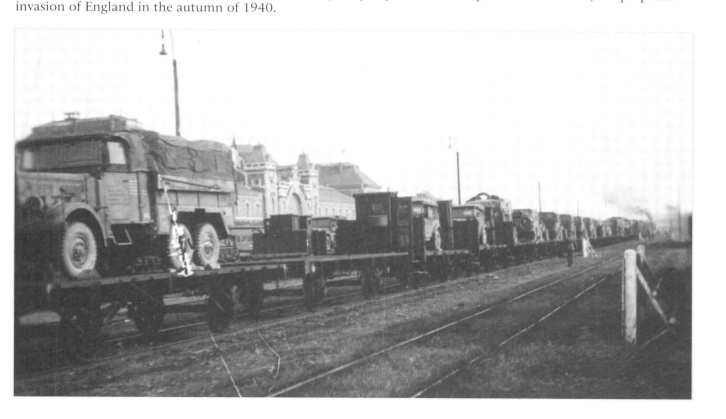

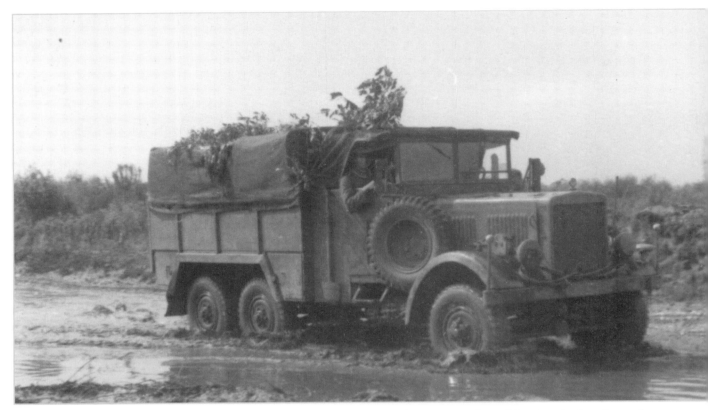

Above: A standard *Einheits-Diesel* in very good condition is seen here in southern Ukraine during the early autumn of 1941. The canvas covers of both the cab and rear cargo bed appear to be in fine fettle. The waterlogged road is proving to be no problem to the all wheel drive of the *Einheits-Diesel*.

Below: Another standard *Einheits-Diesel* in very good condition, this one is on a flatbed rail car in Leipzig's railyard. Seen on the cars behind are a 1934 Ford and behind that a Henschel D-33. Note the unit's tactical symbol on the left-hand mudguards of all the trucks.

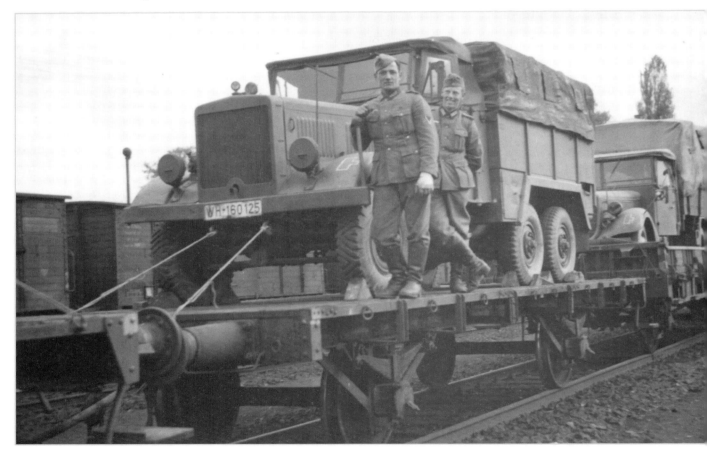

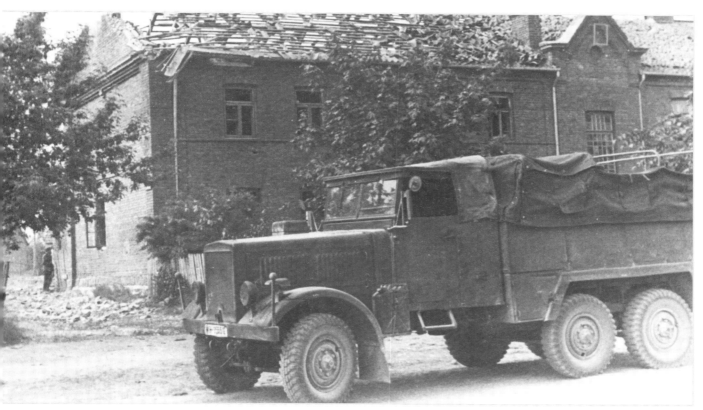

Above: This standard *Einheits-Diesel* is found on the outskirts of Gent, Belgium, during the advance into the low countries and France in the spring of 1940. Of note is the way that the top of the rear canvas tilt is not fitted yet the side panels are. This is certainly not normal and I have never seen it in any other photo in my collection.
Below: Here we see a standard *Einheits-Diesel* in its barracks, located on the outskirts of Dortmund, Germany in 1940, getting ready to leave for an extended trip. I assume it is towing one of the unit's fuel trailers – note the spare tire and fire extinguisher mounted on the front of the fuel trailer.

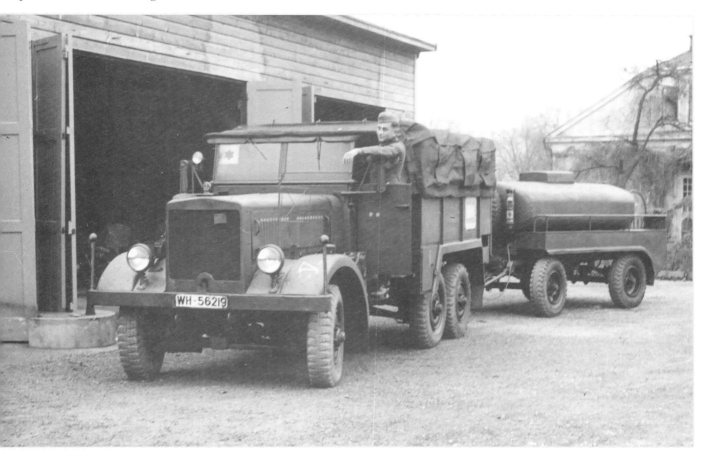

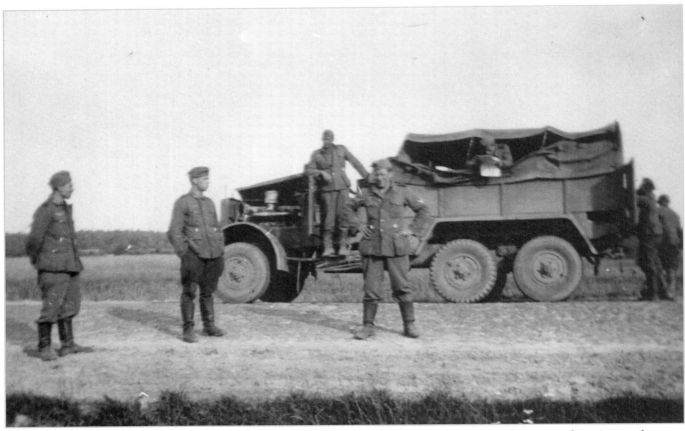

Above: This standard *Einheits-Diesel* is seen at the halt whilst taking part in an exercise somewhere in northern Germany in the summer of 1939. Note the crew are at ease and do not feel in any danger, their relaxed pose is very evident. Also note the soldier reading in the rear cargo bed that has the upper tilt fitted but much of the side panel is unattached.

Below: A vehicle park filled with the transport section of an infantry division also whilst on an exercise somewhere in Germany in the late summer of 1938. Note there are at least two *Einheits-Diesel*s in evidence but also many other types of truck make up the unit's assembled vehicles.

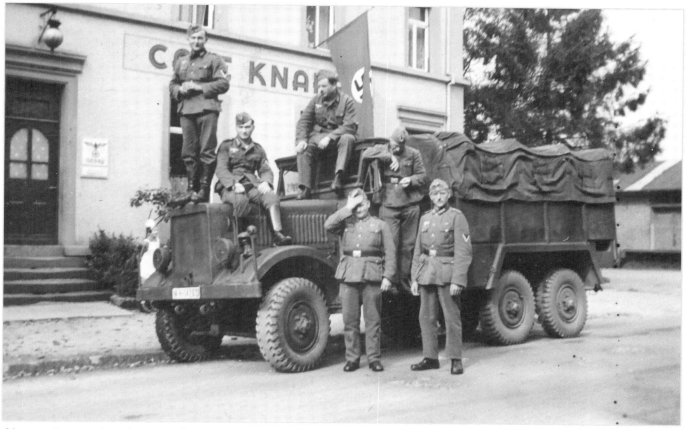

Above: A very nice photograph of the crew and their standard *Einheits-Diesel* as they pose outside a German HQ, based in a hotel and cafe in the occupied Yugoslav town of Mostar in the spring of 1943.

Below: Another very good quality photograph of a standard *Einheits-Diesel*, seen here in its most common of converted types, that of a mobile platform for a field kitchen. This vehicle is in very good condition and is seen in northern France in the summer of 1943.

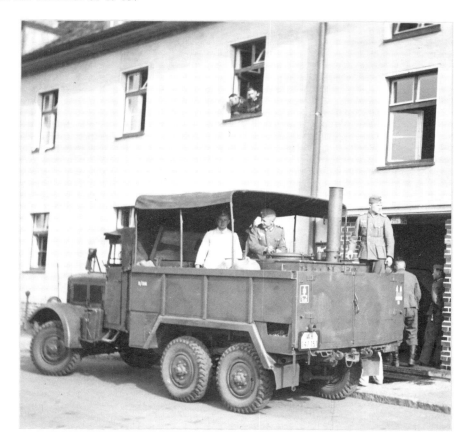

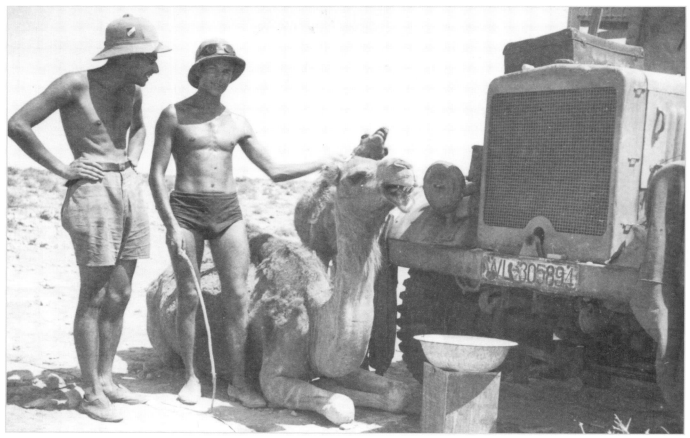

Above: Strange drinking partners. A nice view of an *Einheits-Diesel* in Libya in the winter of 1941. The crew are seen here with a pair of dromedaries – whilst they may have been found just wondering around, I can guarantee they belonged to someone, in my experience they always do. Note the crew are wearing Pith helmets, only issued at the very start of the desert campaign.
Below: A standard body type *Einheits-Diesel* but with its rear cargo bed fitted with ammunition racks for light artillery shells. This photo was taken on the very morning of the invasion of Poland, on the unit's start-line.

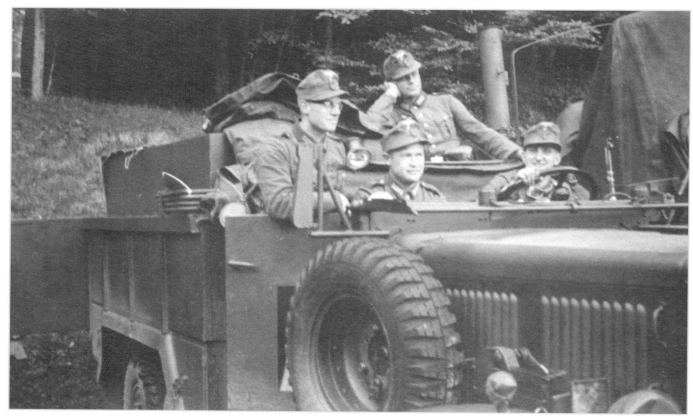

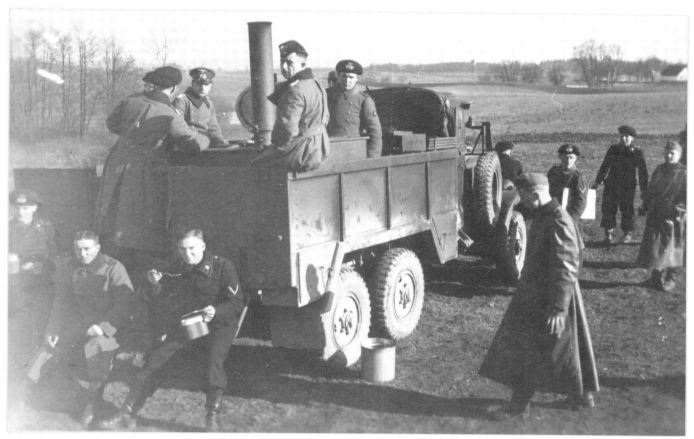

Above: This mobile field kitchen converted *Einheits-Diesel* belongs to the 3rd Panzer Division and is seen here feeding the panzer crews in a field near Toruń, Poland during the second week of the invasion.
Below: Another field kitchen conversion, this time seen feeding an infantry unit somewhere in the highlands of central Yugoslavia during anti-partisan operations in the summer of 1943. Of note are all the ten-man hot meal flasks that are waiting to be filled and then to be delivered to the individual platoons to whom they belong.

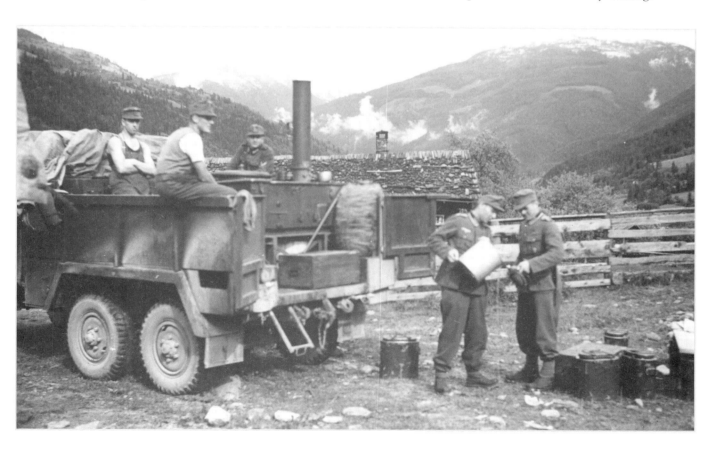

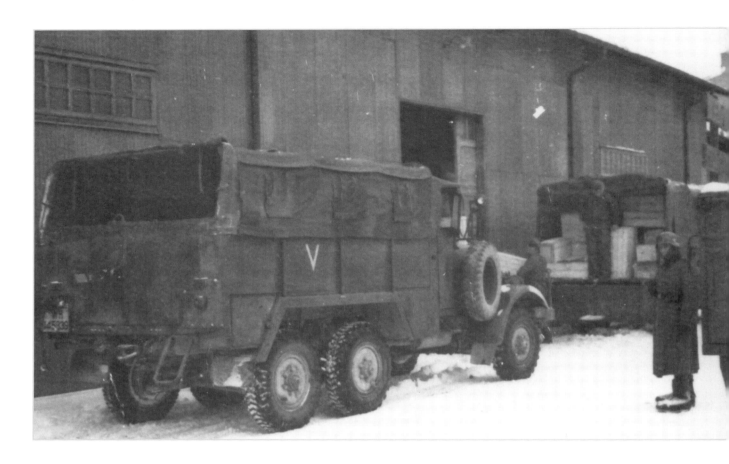

Above: Here we have a nice view of a standard Kfz. 77 *Einheits-Diesel* Ammunition Transport, as denoted by the white letter "V" painted on the side of the rear cargo bed. This photo was taken outside a warehouse in the rail yards of Minsk, Russia on 28th November 1943. Amongst the items of interest in this photo are the number of timber boxes used for the transport of goods and the straw overshoes being worn, an insulation against the cold ground, by the sentry on duty at the rail yard.

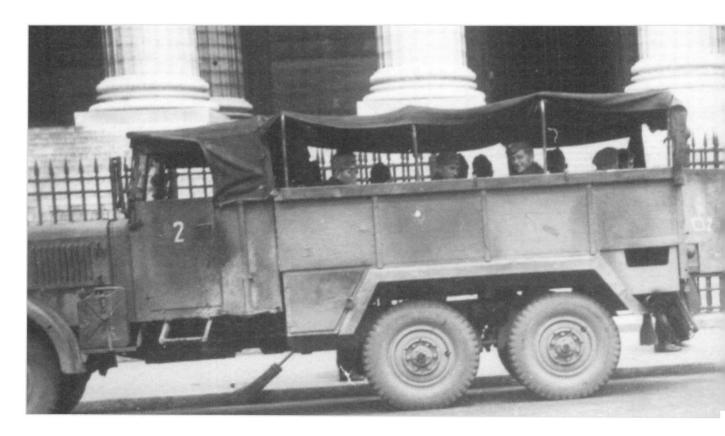

This standard *Einheits-Diesel* is part of a convoy belonging to the 3rd Panzer Division, moving through Belgium in 1940. Note the 1936 type Ford truck alongside the *Einheits-Diesel* and the Henschel D-33 following behind it, yet another example of the huge mix of vehicle types assigned to this unit.

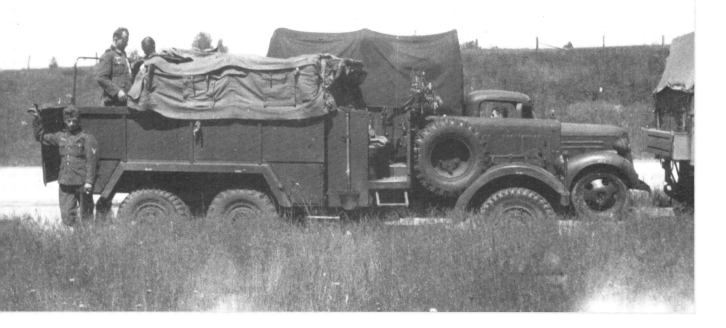

Bottom of both pages: This is a good view of the seating arrangements of this troop carrier version of a standard Kfz. 77 *Einheits-Diesel*. The second vechicle is an ammunition transport version of the standard Kfz. 77 *Einheits-Diesel* but here being used as a troop transport. Note the panzer crew members also standing next to this truck, as this photo came from the same album as other photos of the 3rd Panzer Division. I assume this truck belongs to that unit. This photograph was taken on 2nd June 1940, outside the Place de la Bourse, Brussels, Belgium.

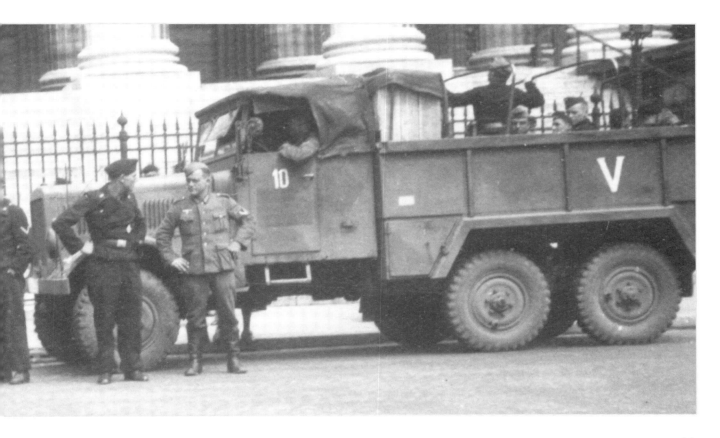

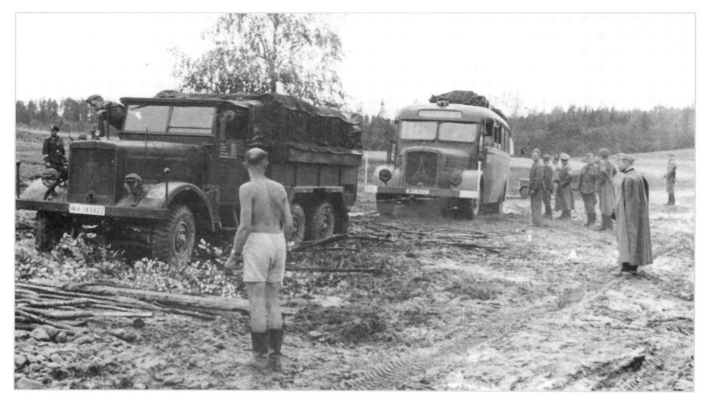

Above: Seen here is an *Einheits-Diesel* utilizing its all wheel drive off-road capabilities to tow a Man bus that is seeing service as a troop carrier, through the first signs of the Russian mud that is just starting to become a problem in the autumn of 1941. This was just the type of use that put too much load on the mechanicals of the *Einheits-Diesel* and ultimately only served to speed its demise. Note here the start of a corduroy road being constructed (wood logs laid down over the mud) and also the passengers from the bus having been off loaded, watching the bus being towed over the hill.

Below: An *Einheits-Diesel* belonging to a motorcycle infantry unit undergoing some light field maintenance outside a farm house in rural Poland. Note the rear tilt that has had longer support loops fitted to its rear section, giving the covered area in the rear more head room than the standard fitted tilt.

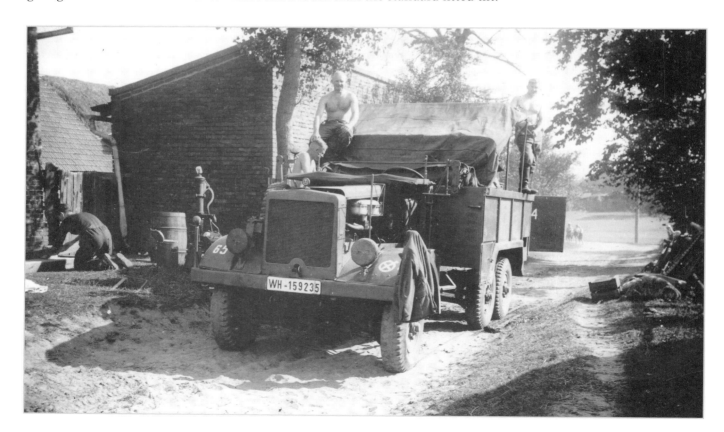

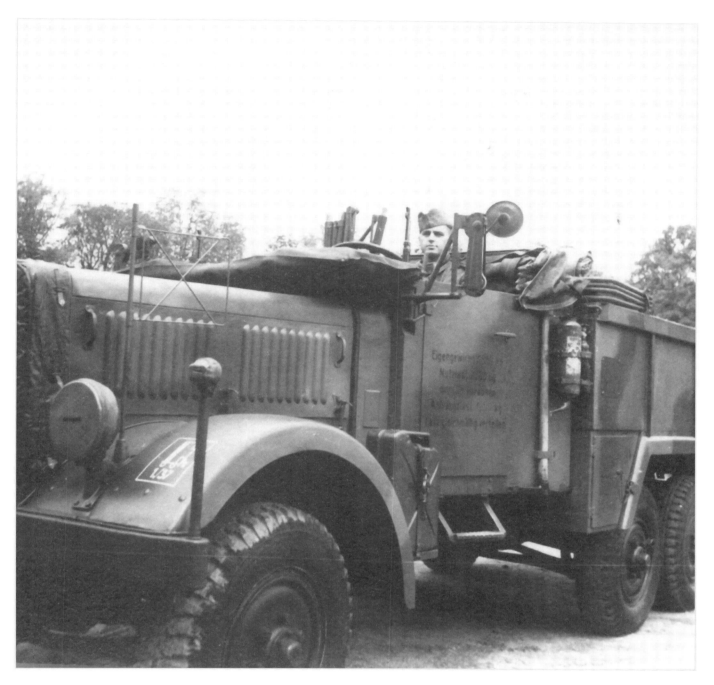

A really good quality close-up photograph of a standard *Einheits-Diesel*. This vehicle is from an early batch, as witnessed by the indicators mounted on the mirror bracket, the pennant frame on the mudguard and the factory-applied three tone camouflage paint scheme. Also of interest is the fire extinguisher mounted on the cab side wall.

This first class photograph of a standard *Einheits-Diesel* named "Hiila" affords us an excellent profile view of the standard configuration of a vehicle with both its canvas tilts raised. Of note is the graffiti on the rear cargo bed's sidewall – this type of chalked-on graffiti was very common on vehicles in service in the field, yet I have rarely seen it depicted on any model of a truck I have seen at a model show.

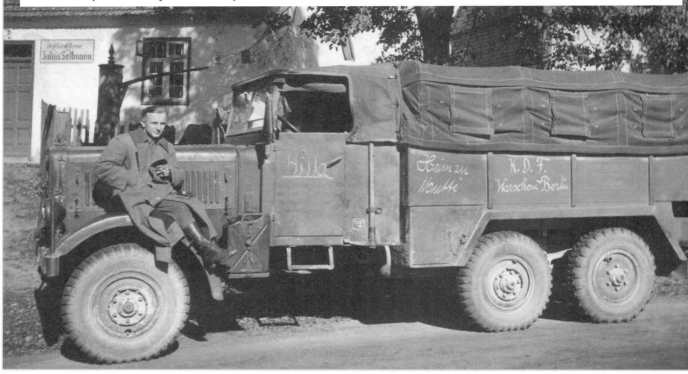

Below: Another fine view of a standard *Einheits-Diesel*, pictured whilst the convoy it is part of is at the halt on the road to Odessa, in the Ukraine. Of note here is the build-up of mud on the vehicle and indeed its general lived in appearance; sadly I can't identify the type of truck following it.

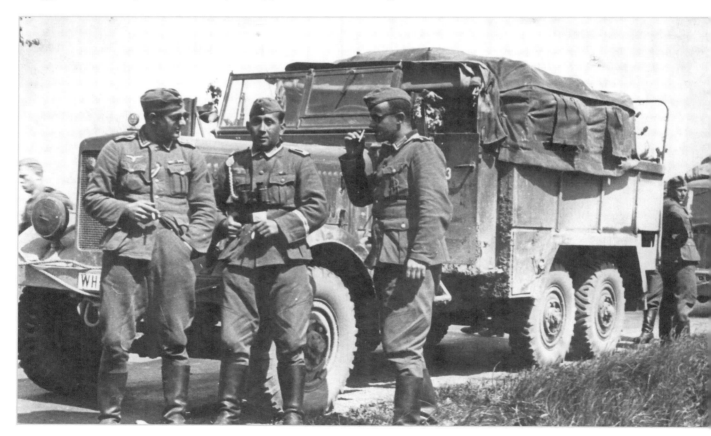

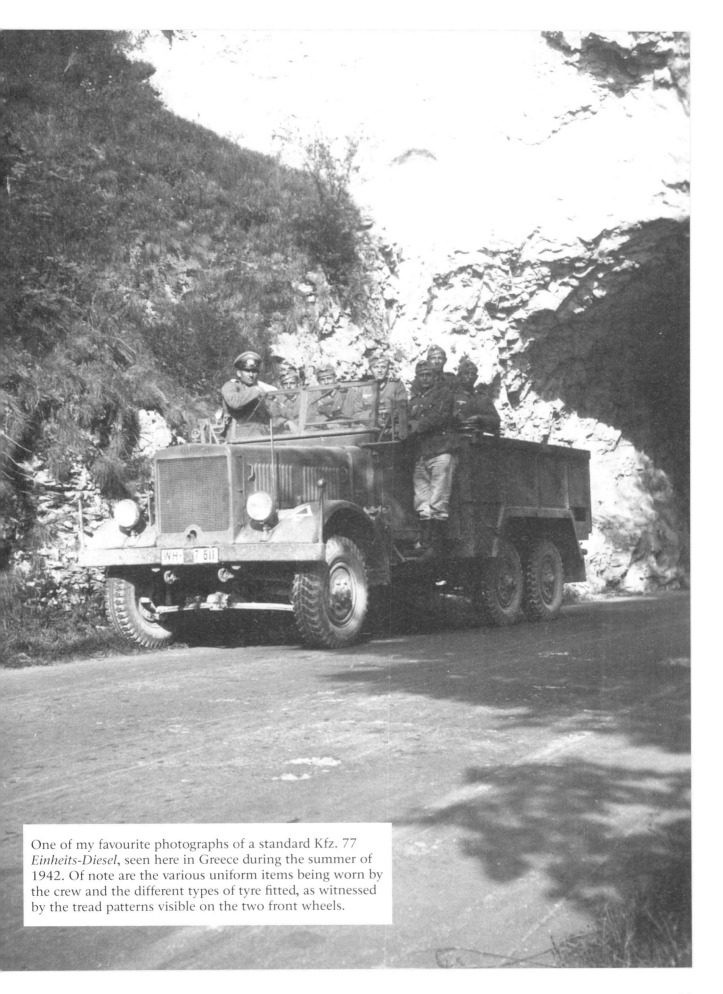

One of my favourite photographs of a standard Kfz. 77 *Einheits-Diesel*, seen here in Greece during the summer of 1942. Of note are the various uniform items being worn by the crew and the different types of tyre fitted, as witnessed by the tread patterns visible on the two front wheels.

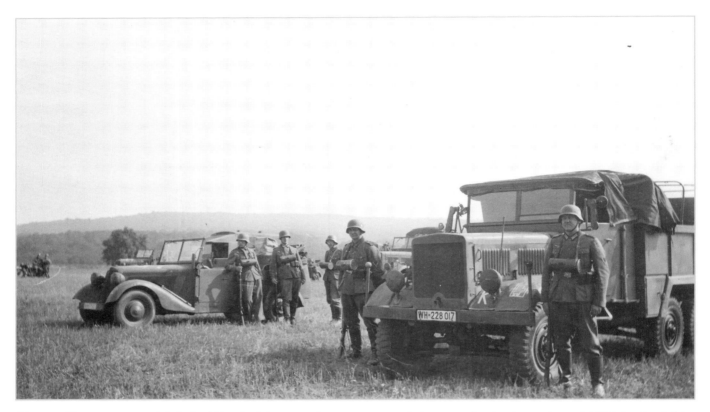

Above: Here we see an *Einheits-Diesel* taking part in a pre-war training exercise in the spring of 1939 in the fields around Hanover. Also seen here taking part is a Mercedes 170 radio car. Of note is the way in which all the soldiers are wearing their gas masks in the style of motorcyclists.

Below: A line up of *Einheits-Diesel*s, all being used as mobile field kitchens, and a gathering of the catering staff from the 3rd Panzer Division. This photograph was taken on the evening before the invasion of Poland in 1939. Note the early production vehicle at the front of the row still retains its factory applied three tone camouflage scheme.

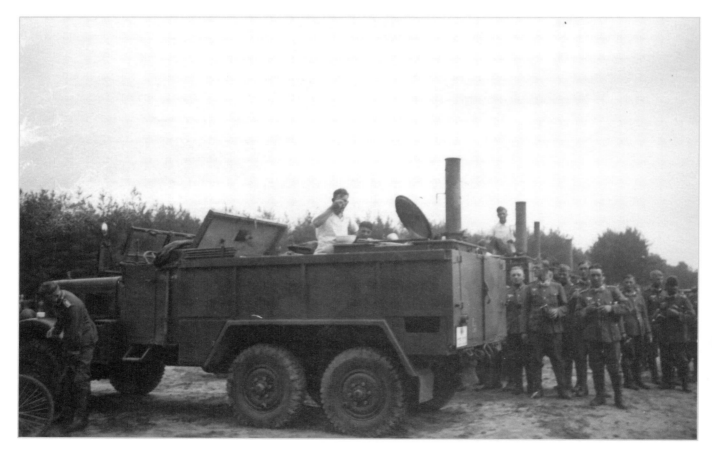

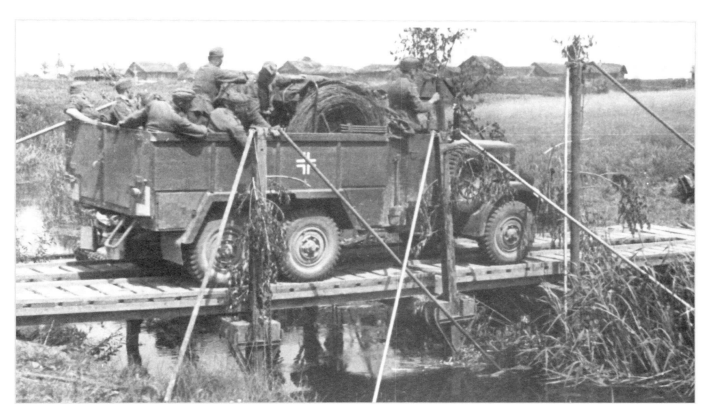

Above: A very interesting photo of a *Einheits-Diesel* crossing a standard German pattern field engineering bridge over a small river, just outside a small Russian town. Note the crew all sitting at the rear of the cargo bed whist the front is loaded with rolls of barbed wire, still with their protective wooden plank wrap to aid in handling them as a single load.
Below: This *Einheits-Diesel* is seen in Crete and has been converted by its crew by the addition of a timber extension to the rear cargo bed to raise its height, which has been covered by a tarpaulin with the addition of a roll-up side panel. I am not sure of the use of this vehicle but it may be being used as a field improvised radio truck as in another photo I have it is in the distance next to a standalone aerial mast.

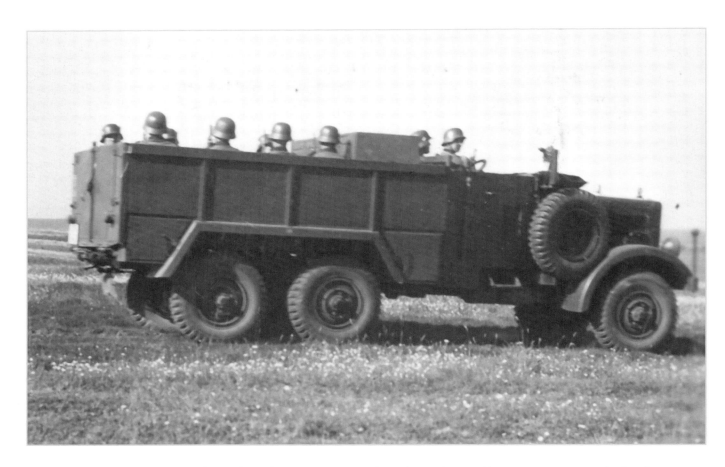

Above: Sadly this is not a high quality photograph but it does show the small arms ammunition locker location in the front of the cargo bed in the troop carrying variant of the *Einheits-Diesel*. This photo dates from the summer of 1940 but I have no more information.
Below: Nice front right view of this *Einheits-Diesel* with full complement of wet weather gear fitted. This vehicle is driving through a bombed out suburb of Rotterdam, Holland in the autumn of 1940.

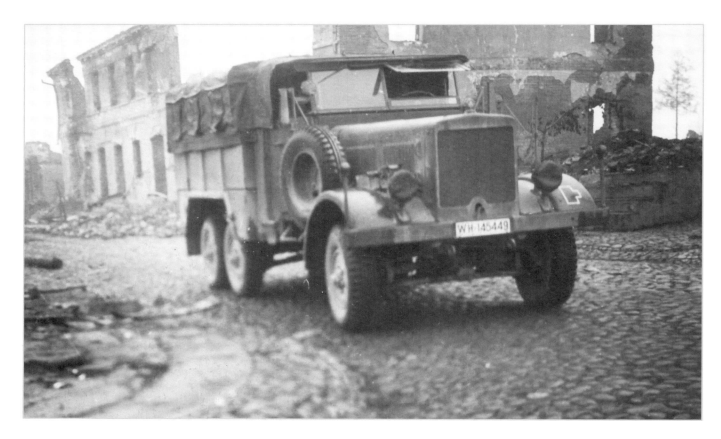

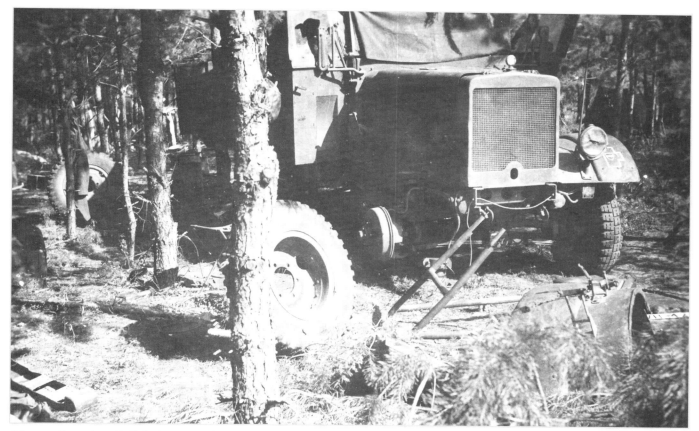

Above: Seen in a Polish forest undergoing some field maintenance, this *Einheits-Diesel* has suffered brake failure and is having new brake lines fitted. Whilst driving over a felled tree the trunk rotated and broken branches caught the brake pipes and ripped a length out and damaged much of the rest. Overall a small repair but much of the vehicle has to be disassembled in order to get to the brake lines.

Below: An *Einheits-Diesel* belonging to an engineering unit loaded on a rail flatbed, seen in the rail yard in Split, Yugoslavia, in the late summer of 1940. Of note are the wooden chocks that are holding the *Einheits-Diesel* in place on the flatbed, a feature usually forgotten in any model, and the standard field engineering trailer on the flatbed behind.

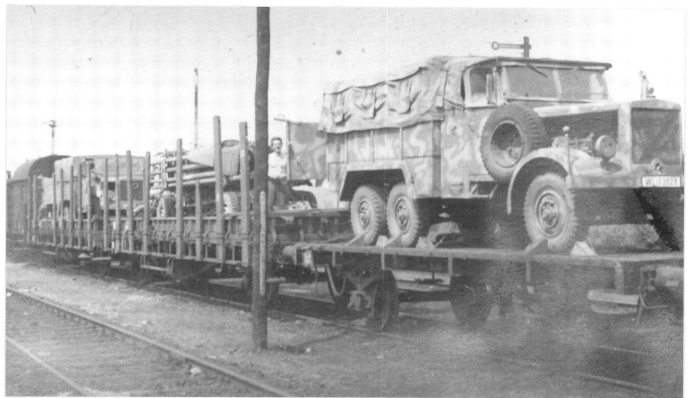

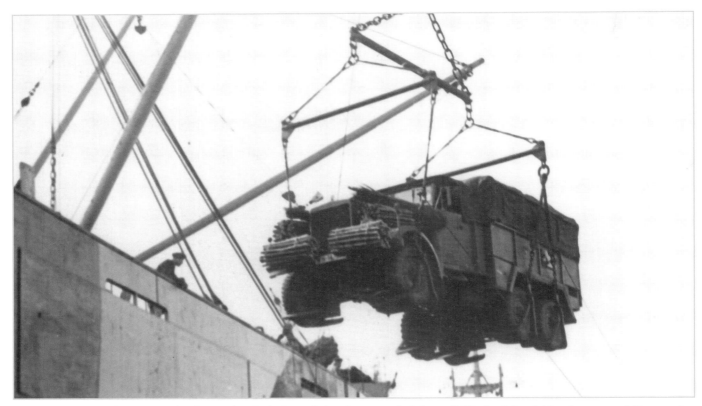

Above: This *Einheits-Diesel* is being loaded aboard the German freighter *Wilhelm Mendel* in the port of Genoa, Italy, on route to Africa to become part of Rommel's Africa Corp. Note it still has the rolls of timber attached to the front wings that are to be used to assist with the wheels that have become stuck in mud. Whilst they may not see mud where they are going, the rolls of timber will serve just as well in soft sand

Below: An *Einheits-Diesel* undergoing maintenance in a vehicle park in France during the month of June 1940. Whilst this photo offers us a good view of the engine compartment, what I find of interest is the mechanic holding a lit cigarette close to the fuel system – "Oh how things have changed".

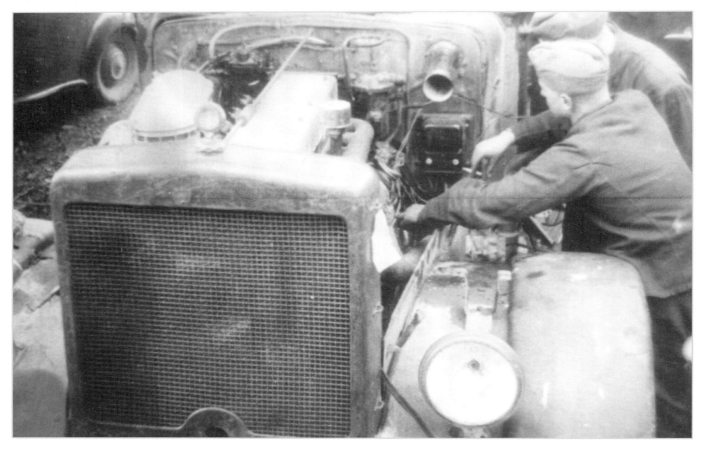

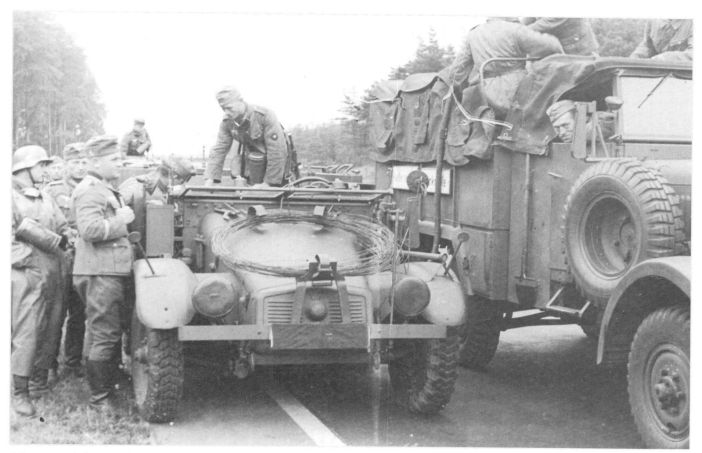

Above: Whilst on the advance into France, a column of vehicles halt to review the route they are on; the advance was so fast it often outstripped orders. Here we see an *Einheits-Diesel* parked alongside a Kfz. 69 Krupp Protze. Of interest are the anti-glare cover over the number plate and the barbed wire roll mount on the front of the Krupp, also the motorcycle dispatch rider on the far left of the photograph.

Below: Here we have a very nice close up of the front end, engine compartment and drivers cab of a standard Kfz.77 *Einheits-Diesel*, this view offers great detail of the cabs removable side door window panels and also the correctly fitted and cab roof of note is the as new condition of both. The side window panel rarely lasted for log as the clear early compound of plastic (acetate) panel was very brittle and prone to cracking and splitting; it suffered from UV degradation quickly and yellowed usually within months.

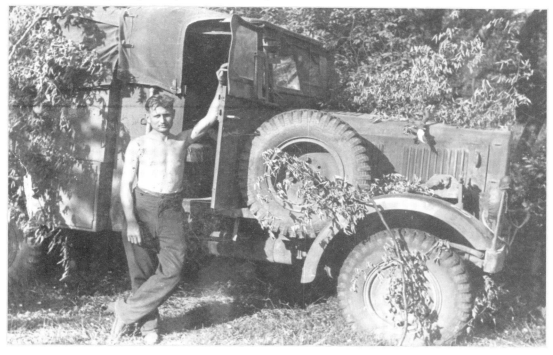

Right: A great study of a driver in his summer uniform proudly standing next to his *Einheits-Diesel*. This photo was taken on 16th July 1942 near Sarajevo, Yugoslavia. (Today: Bosnia & Herzegovina.) Of note is the unit's tactical symbol painted above the loading weights list panel on the driver's door, a most unusual place to find it.

Bottom: Another good study of a crew posing next to their *Einheits-Diesel*, this time next to their billet in Leiden, Holland, in the autumn of 1942. Note the DKW 500cc motorcycle and sidecar in the foreground.

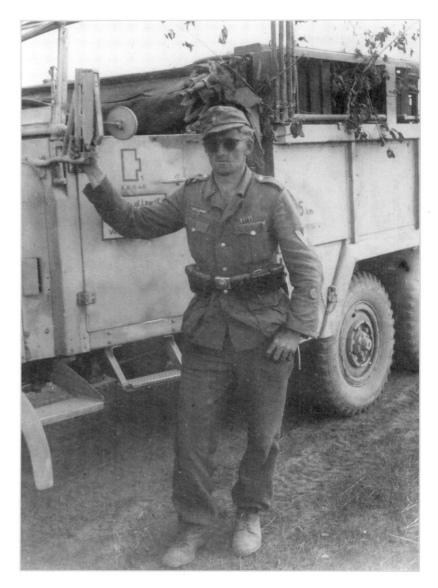

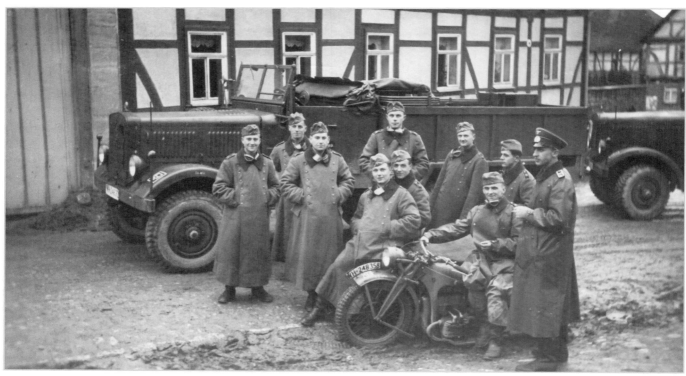

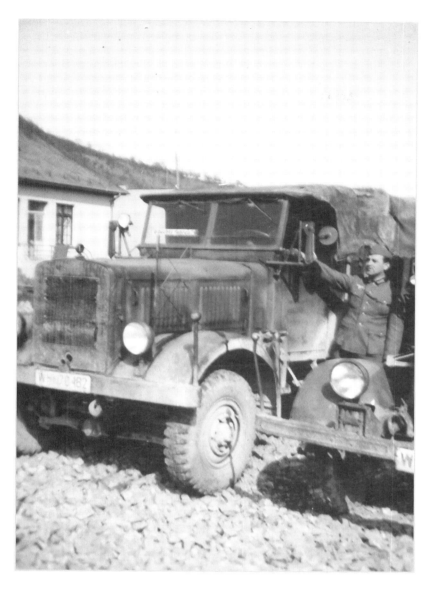

Left: This *Einheits-Diesel* is parked next to a number of other vehicles that have been stripped for spare parts in a vehicle park in southern Russia in the summer of 1943. It is possible that this vehicle was previously crewed by the driver photographed here, as on the back of the photograph it states that "I have driven this one". I am not sure that this truck is part of the spares stock, though, as it appears to be in rather good condition, all things considered.

Bottom: The crew of this *Einheits-Diesel* pose in a very happy mood, having just received an allocation of rations and, as any old soldier will tell you, that is usually the high point of any day. Of note here is the amount of written information stencilled onto the driver's door – it appears to be much more than just the usual shipping weight information.

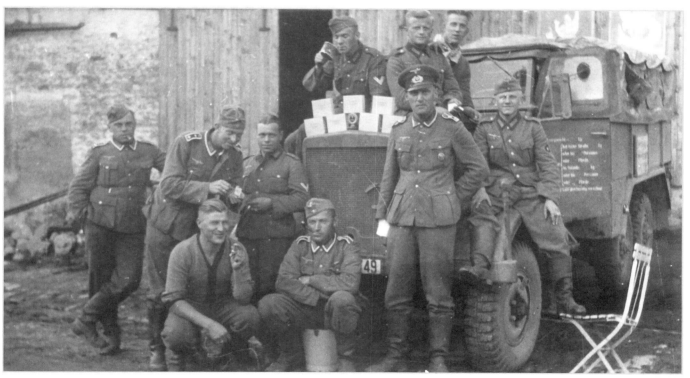

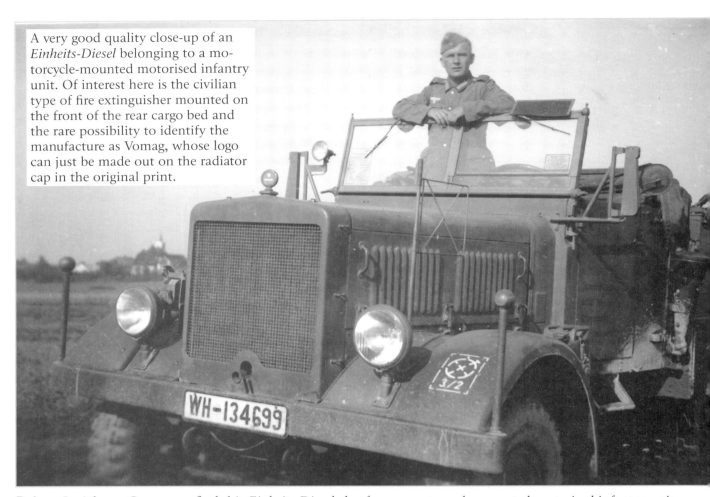

A very good quality close-up of an *Einheits-Diesel* belonging to a motorcycle-mounted motorised infantry unit. Of interest here is the civilian type of fire extinguisher mounted on the front of the rear cargo bed and the rare possibility to identify the manufacture as Vomag, whose logo can just be made out on the radiator cap in the original print.

Below: In Athens, Greece, we find this *Einheits-Diesel* also from a motorcycle-mounted motorised infantry unit, with some of the unit's members posing for a group photograph both in and around the truck. The vehicle appears to be loaded with motorcycle spares, certainly a motorcycle wheel is clearly visible.

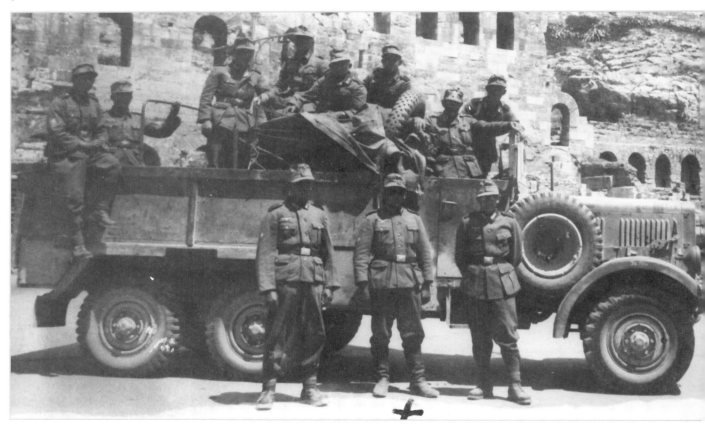

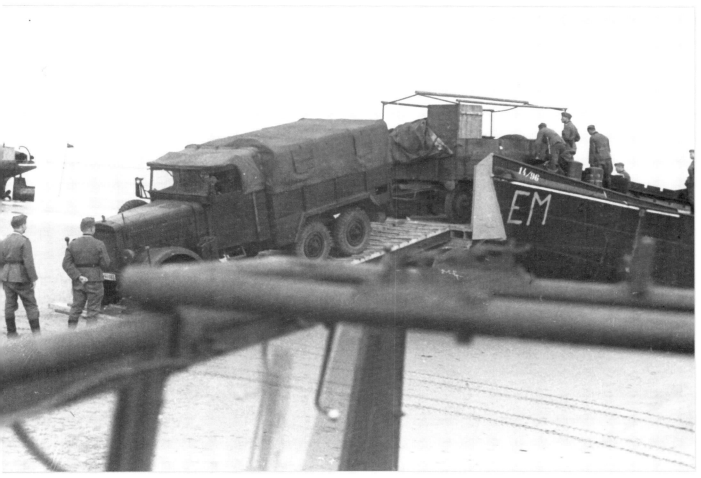

Above: On a beach in the Pas de Calais, this *Einheits-Diesel* is taking part in a practice exercise disembarking from a converted coal barge, in preparation for the planned invasion of England (Operation Sea Lion) in the summer of 1940.

Back to food – here we see an *Einheits-Diesel* being used to collect a harvest of turnips, with the assistance of three generations of a farming family. The purchasing of local produce was commonplace during the occupation of France, whereas in many other areas under German control produce was simply commandeered.

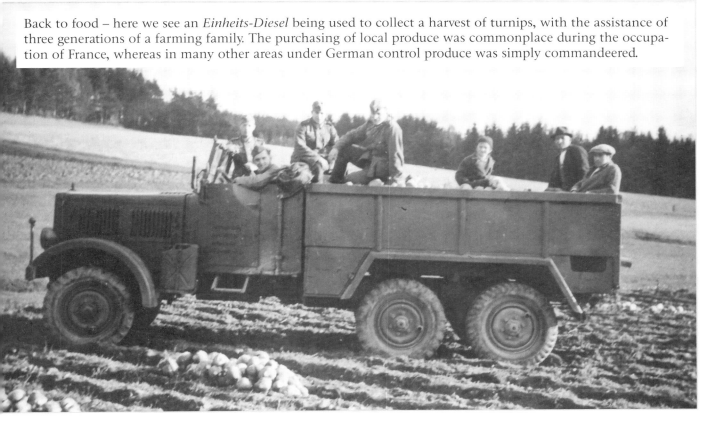

Seen here in central Russia during the summer of 1942, we have an *Einheits-Diesel* whose crew have become used to the fact they can no longer expect to have *Luftwaffe* air support and that local control of the air space over their heads may not be under German control. Hence the crewman sitting on the front fender (mudguard) as an aircraft spotter. This practice became more common, and indeed necessary, as the war progressed.

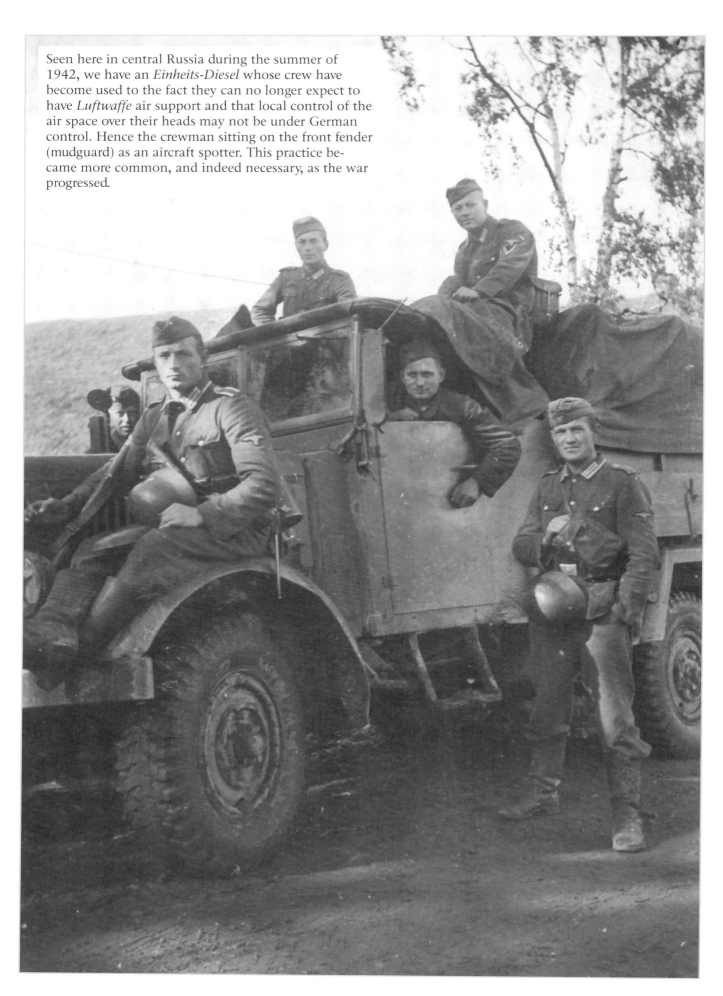

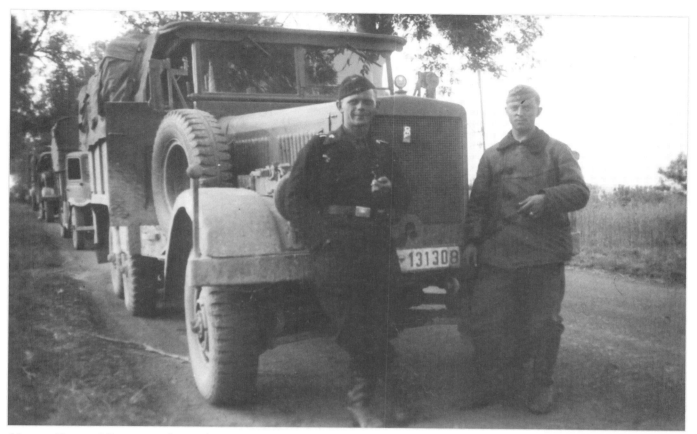

Above: Two soldiers pose for a photograph in front of this *Einheits-Diesel*. The driver is wearing his wet weather gear and a panzer crewman is in his all black two piece battle dress. This convoy of trucks belong to the supply-train of the 3rd Panzer Division and are photographed here in northern Belgium in May 1940.

Below: A standard Kfz. 77 *Einheits-Diesel* is seen here parked on a road in the German Ardennes on the day of the invasion of France. This must be towards the rear of the column, as there is still a mood of general calm, Two German children still play on the road, excited by the military presence no doubt. Of note is the infantry officer passing a written order to the panzer corps trooper.

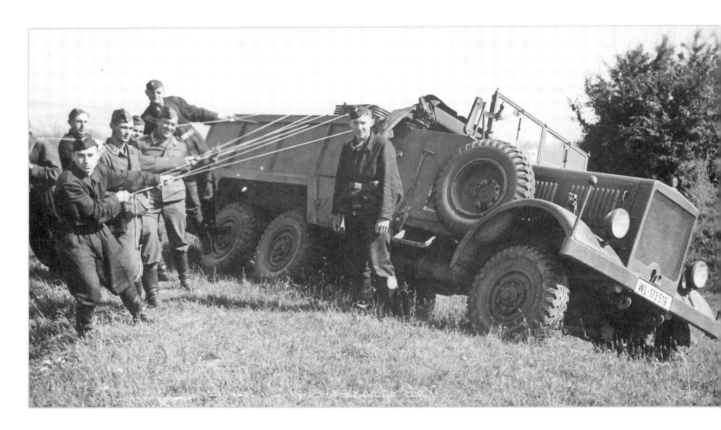

Above: This *Einheits-Diesel* has rolled onto its side whilst traversing this small incline and has just been pulled back onto its wheels by having many small ropes attached to the tilt fastening points on the left-hand side, which the crew and other seconded soldiers have managed tug on to pull it back over manually. Once the photo has been taken and whilst the troops still pull on the ropes to ensure it does not roll again, the truck was driven to a flatter area and reloaded, as witnessed in a subsequent photo from the same album.

Below: A very good quality photograph of a standard *Einheits-Diesel* that has run over a mine and lost its front right-hand wheel, mudguard and bumper. The blast has also blown away the engine cover panels. As bad as this damage looks, the album notes state that the truck was recovered, repaired and back in service within two weeks.

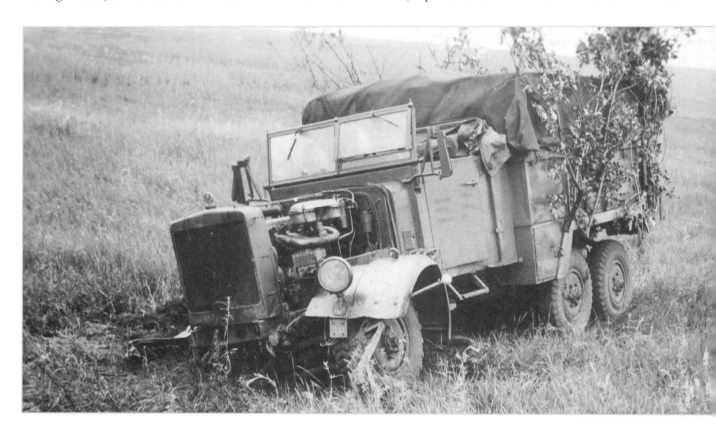

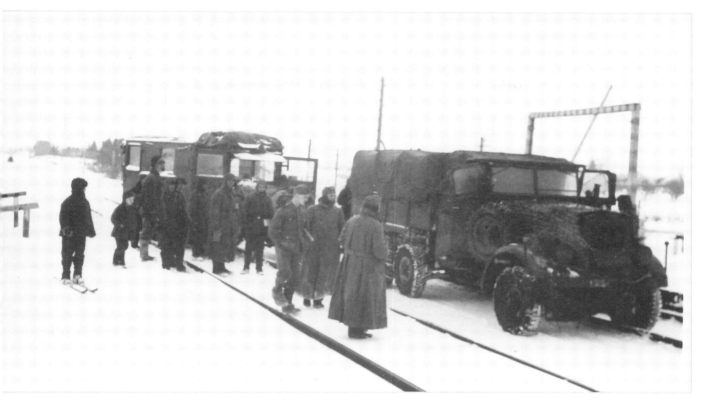

Above: On a very clear but cold day somewhere near Kharkov, Ukraine, part of Army Group Centre's front in the winter of 1941/42. We see here an *Einheits-Diesel* fully covered and with even bundles of reeds made into a mat to cover the engine compartment, to try and help keep the engine warm. The lack of purpose made or fit for service equipment to cope with the Russian winters was a problem the German army never fully solved, and in 1942 had not even begun to come to terms with.

Below: In stark contrast to the previous photograph we see here on a bright and sunny spring day in northern Austria an *Einheits-Diesel* towing a Kfz. 69 Krupp Protze artillery tractor variant. Unfortunately I have no other information on this photo but it appears to have been taken in 1939 or 1940, as the camouflage on the Krupp is still the three-tone pre-war colour scheme, yet the truck is in overall panzer grey.

Although this photograph of an *Einheits-Diesel* is not the focus of the photo, I have included it as I think it is an ideal example for a diorama. It does include an excellent clear view of the spade location point on the side of the cab wall and the folded back cab cover.

Below: A nice close-up of the rear of an *Einheits-Diesel* belonging to the 2nd SS Panzer Division, that is being used as mobile platform for a field kitchen. This photo was taken in the unit's barracks in the summer of 1939.

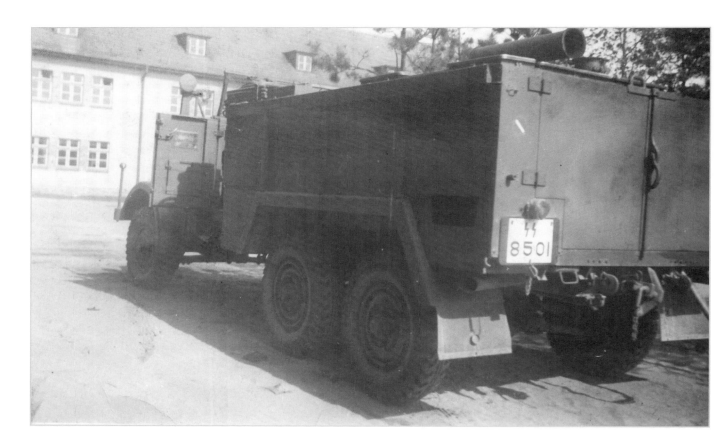

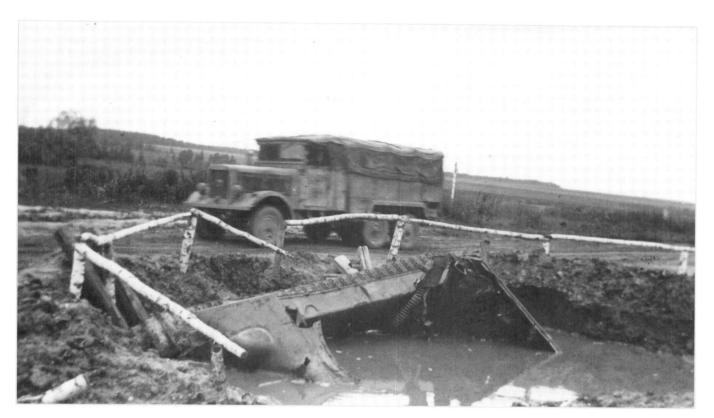

Above: Here we have an atmospheric photograph of an *Einheits-Diesel* travelling at speed along a mud road in central Russia. Whilst the truck is a bit muddy it appears to be in generally good condition with its wet weather covers fully erected. Of interest here is the silver-birch log fence around a bomb crater that contains the remains of the bomb's target – a T-34 that has been thoroughly destroyed.

Below: A very curious photograph – a member of the crew of this *Einheits-Diesel* is beating something against the side of the vehicle and another is holding a stick, the rest all look to be in a jovial mood. The truck is in full wet weather condition and even has a radiator cover in place. This photograph was taken near or in the port of La Rochelle, France in the spring of 1942.

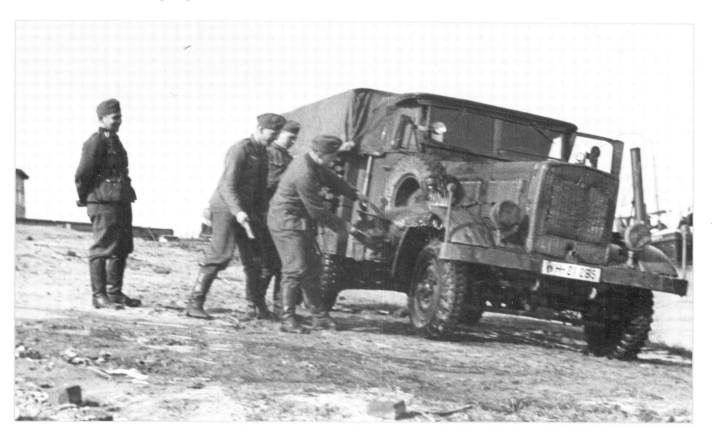

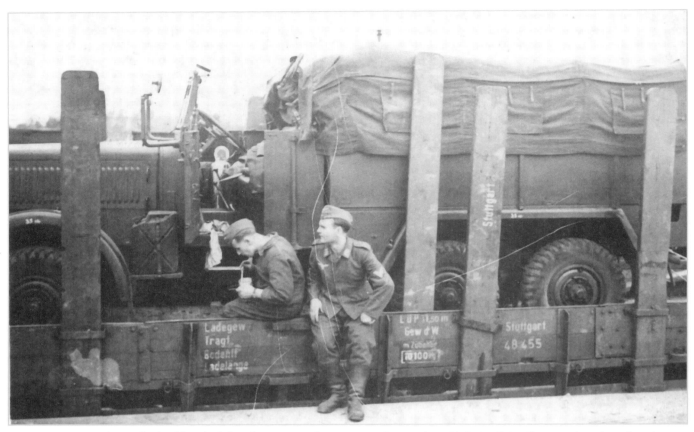

Above: On a railway flatbed loaded for the trip to the Russian front, this *Einheits-Diesel*'s crew is using the time to do some maintenance on something removed from the cab. The photo was taken in the railyards in Leipzig on 15th July 1940.

Below: This high quality photograph shows a Luftwaffe mobile signal unit's *Einheits-Diesel* moving through a picturesque village somewhere in Luxemburg. Unusually, due to the clarity of this photograph on the original print, the manufacturer's logo can be identified – this truck was produced by Faun and is in as new condition.

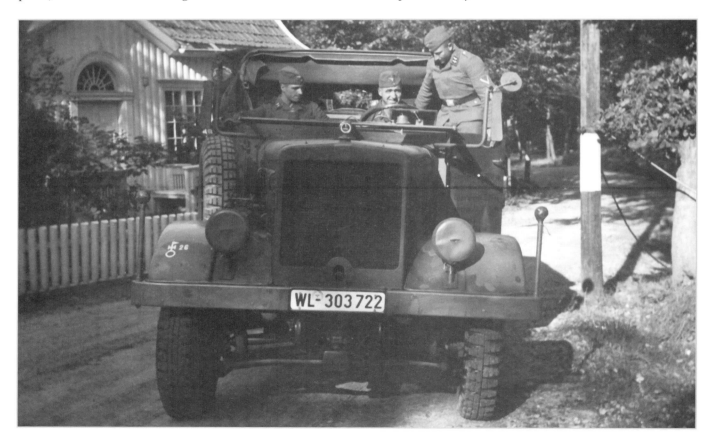

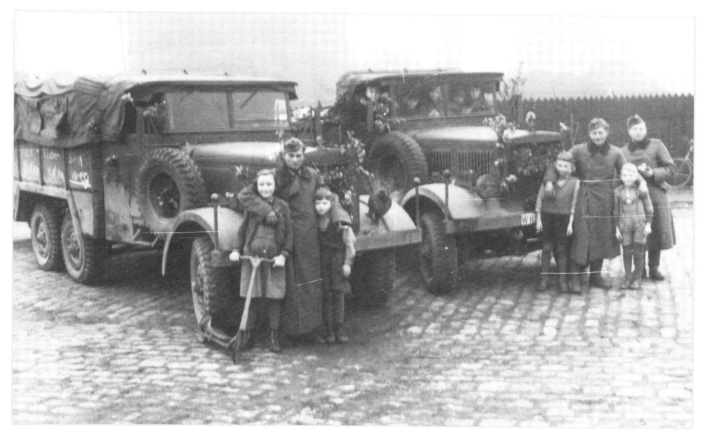

Above: "Hearts and Minds" 1930's style. This photograph of two *Einheits-Diesel*s was taken in an industrial area on the outskirts of Vienna, Austria. Of note is the welcome by the local Austrian children and the graffiti written on the sides of the trucks' rear cargo beds.

Below: An *Einheits-Diesel* with its cab tilt raised and the rear roof tilt in place, but the side covers, although fitted, have been rolled up. Of more note is the field produced trailer that has been made from the complete rear cargo area of another truck. The cab section was removed and a straight through axle fitted, with a welded frame attached to the chassis members to fit a towing hitch.

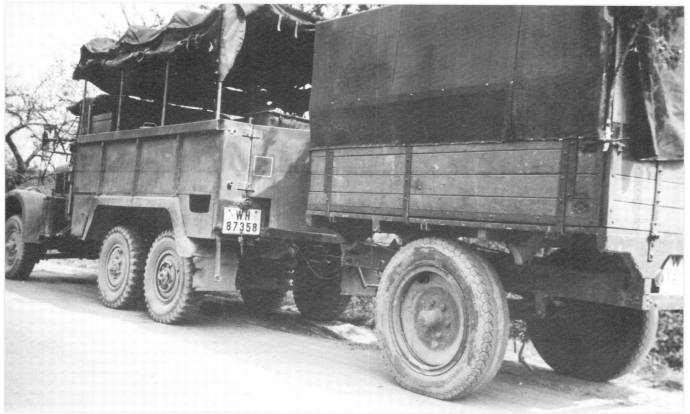

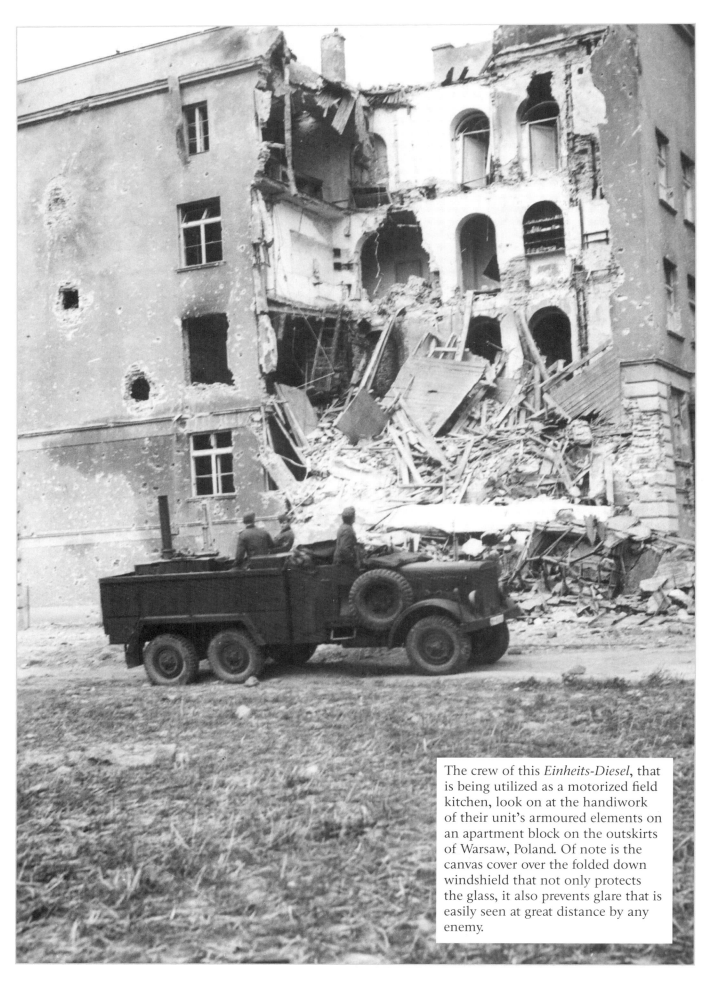

The crew of this *Einheits-Diesel*, that is being utilized as a motorized field kitchen, look on at the handiwork of their unit's armoured elements on an apartment block on the outskirts of Warsaw, Poland. Of note is the canvas cover over the folded down windshield that not only protects the glass, it also prevents glare that is easily seen at great distance by any enemy.

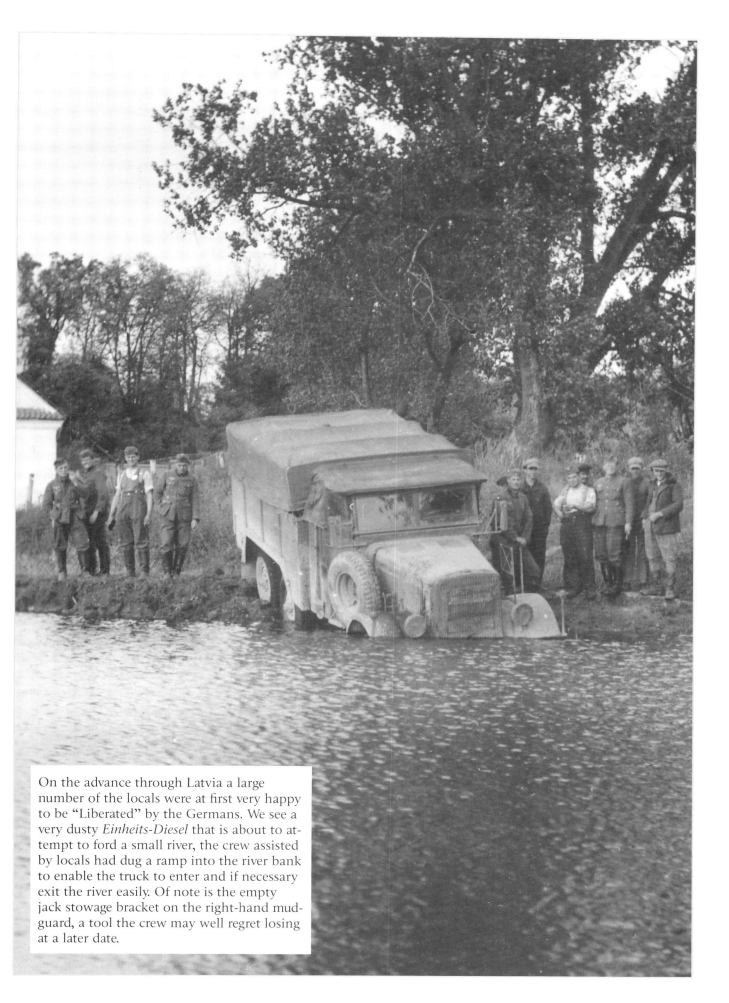

On the advance through Latvia a large number of the locals were at first very happy to be "Liberated" by the Germans. We see a very dusty *Einheits-Diesel* that is about to attempt to ford a small river, the crew assisted by locals had dug a ramp into the river bank to enable the truck to enter and if necessary exit the river easily. Of note is the empty jack stowage bracket on the right-hand mudguard, a tool the crew may well regret losing at a later date.

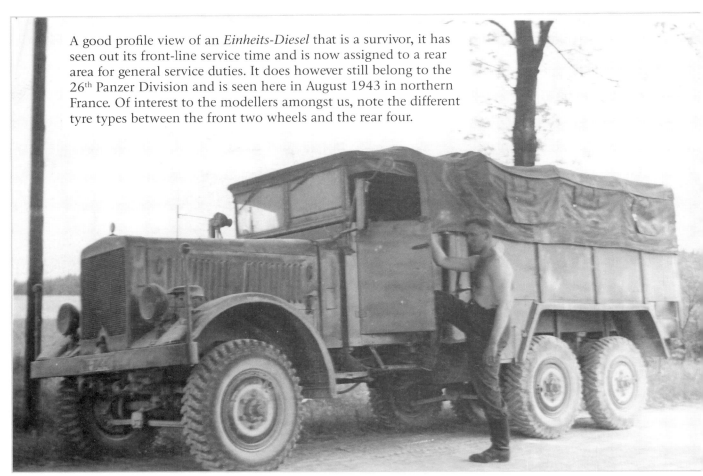

A good profile view of an *Einheits-Diesel* that is a survivor, it has seen out its front-line service time and is now assigned to a rear area for general service duties. It does however still belong to the 26th Panzer Division and is seen here in August 1943 in northern France. Of interest to the modellers amongst us, note the different tyre types between the front two wheels and the rear four.

Below: Another survivor from the 26th Panzer Division now on rear area duties, this time parked up outside a warehouse that is being used as a barracks by Panzer grenadiers. Th truck has been amended from factory spec by having a higher rear tilt fitted to increase the rear cargo area, and has also been covered to hide from the overwhelming allied air superiority by the application of a camouflage net and various wooden scrap items lent against it.

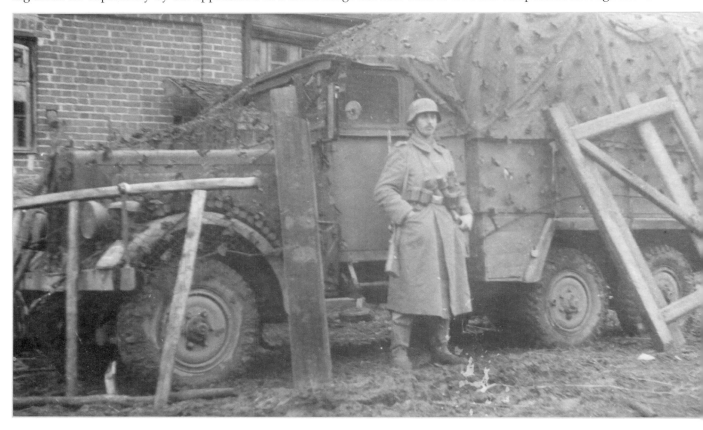

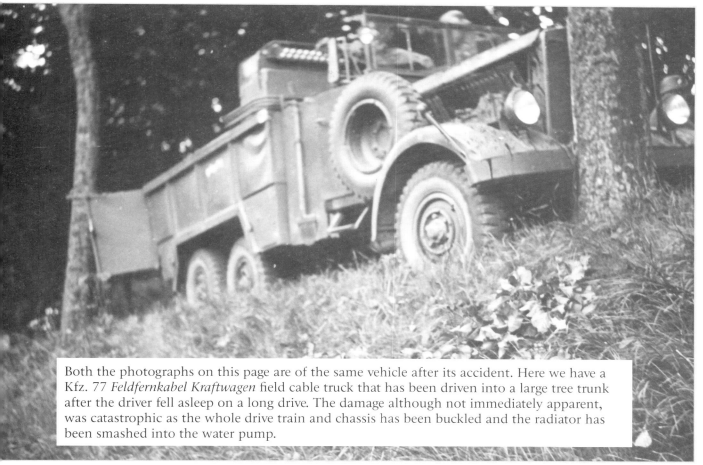

Both the photographs on this page are of the same vehicle after its accident. Here we have a Kfz. 77 *Feldfernkabel Kraftwagen* field cable truck that has been driven into a large tree trunk after the driver fell asleep on a long drive. The damage although not immediately apparent, was catastrophic as the whole drive train and chassis has been buckled and the radiator has been smashed into the water pump.

Below: Careful examination of this *Einheits-Diesel* field cable truck shows that even the rear cargo bed has been buckled by the cab body being forced backwards into it. Indeed compare this photo with any other in this book and you can see that the engine compartment of this one looks to be much shorter than any other example. Ultimately this truck proved to be unrepairable.

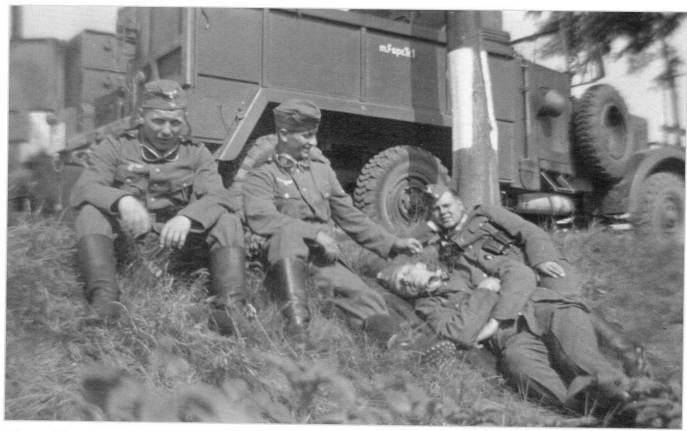

Above: The crew of this *Einheits-Diesel* are having a rest on the embankment of a road in central France. The truck they are crewing is a battery-charging vehicle, some of the accumulators are visible through the open rear door. Of note is the steel helmet hanging from the cab door handle and the vehicle's designation stencilled onto the side of the cargo bed.

Below: This *Einheits-Diesel* belonging to the SS Division *Das Reich* is a standard troop carrier version, but is also being used as an addition to the maintenance unit's motor pool attached to the armoured element of the division. This group of SS troopers are preparing lunch; on the table are their individual canteen sets.

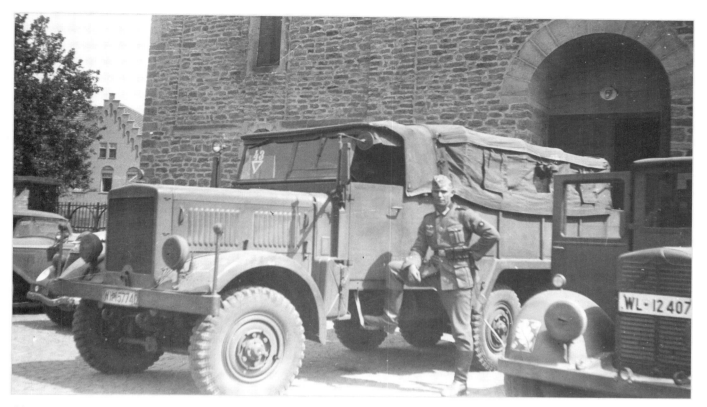

Above: Here we see a standard *Einheits-Diesel* parked in the town square of a Dutch town in the summer of 1940. Of note here is that the assembled collection of vehicles all belong to the German *Luftwaffe*, next to the *Einheits-Diesel* in the foreground of the photograph is a very common yet rarely documented Phänomen Granette 1.5 ton light truck variant this one is an ambulance.

Below: A classic view of a standard Kfz. 77 *Einheits-Diesel* troop carrier version belonging to a towed artillery unit attached to Von Kleist Battle Group on the advance into southern Russia. This vehicle has all the extras, wood fascines attached to the front bumper, a flag for recognition from the air over the engine compartment and a cover for the folded down windshield. Also of note are the extra 20 l Jerry cans mounted to the tops of both front fenders, held in place by brackets produced in the field.

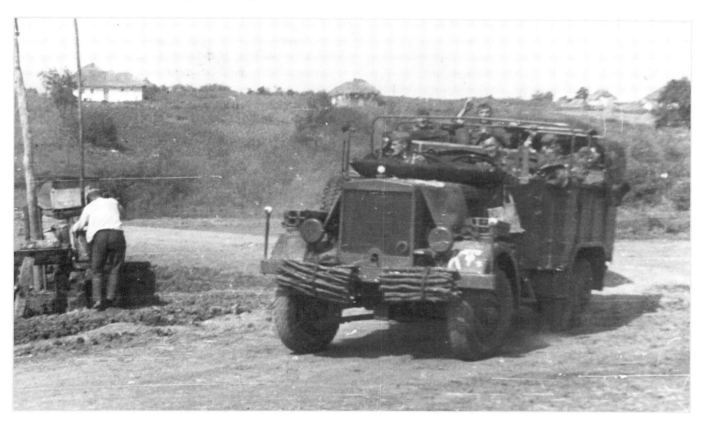

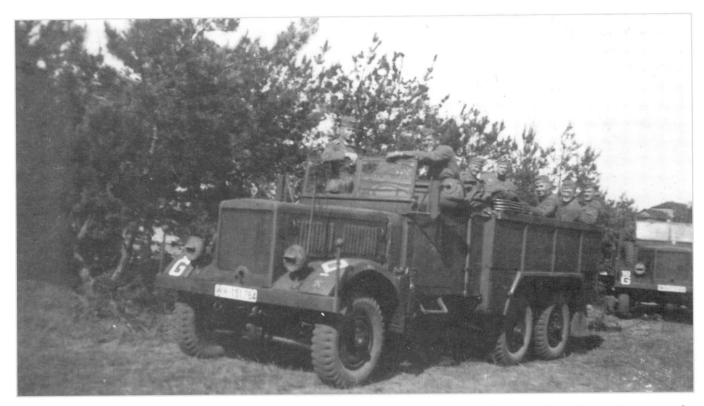

Above: In this photograph we see two standard *Einheits-Diesel* troop carrier versions on the advance into central Russia, both belonging to General Guderian's Battle Group. The vehicle in the foreground is totally as delivered from the factory. Note the small headlights and lack of a pennant bracket fitted to the left-hand fender, both features of a late production vehicle.

Below: This column of *Einheits-Diesel*s are on the advance into the west. The photograph was taken in the small Belgium town of Aalst just north of Brussels. Of note is the small cut-out in the rear mudguards – this was for a triangular tool box that was fitted on the Kfz. 63 variant of the *Einheits-Diesel* and the last few standard production Kfz. 77s. Whilst the cut-out is in evidence the tool box has not been fitted.

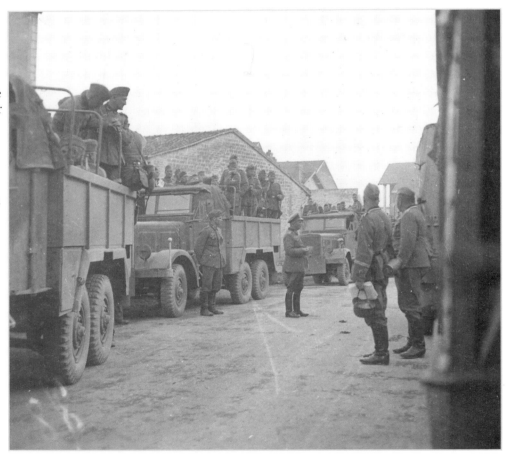

Above: Here we have a photograph of an *Einheits-Diesel* belonging to the 12th Panzer Division's associated artillery unit, as witnessed by the white letter V painted on the rear cargo bed's sidewall, which denotes that this vehicle is designated to transport ammunition. The 12th Panzer Division was part of the Von Kleist Battle Group during the invasion of Russia in 1941.

Below: Seen in a vehicle park in the town of Kielce, Poland, on the morning of 6th September 1939 we have two *Einheits-Diesel*s, a 1930's Ford and a Borgward 3 ton truck. Note the non-standard raised tilt over the rear cargo bed of the first truck compared to the factory standard tilt on the second truck in the row.

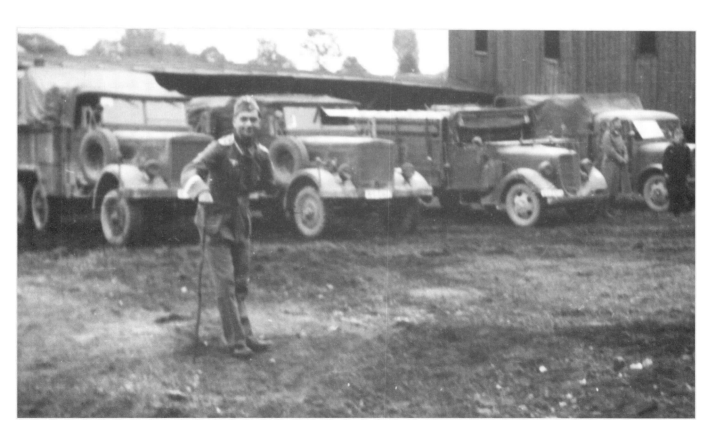

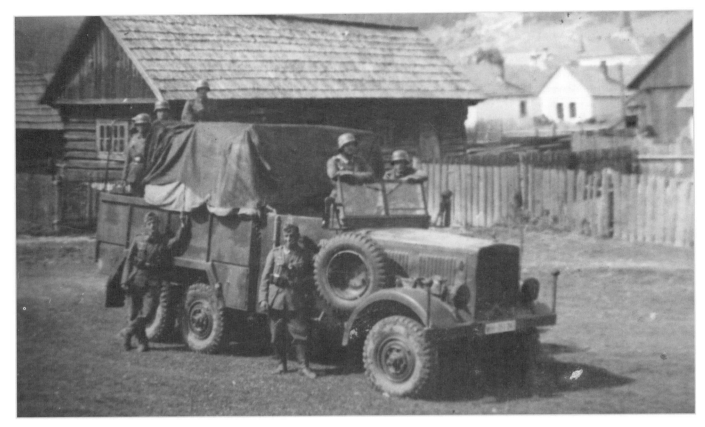

Above: Found in a field next to a small Norwegian town is an *Einheits-Diesel* onto which the crew have fitted a raised rear cover over the rear cargo bed. Of interest is the rough camouflage scheme applied over the standard overall Panzer grey factory paint.
Below: This Kfz. 63 variant of the *Einheits-Diesel* is part of Rommel's Africa Korps seen in Libya during 1941. This variant is an artillery ranging vehicle. Of note in this photo is the Africa Korps emblem painted onto the cab door and that the driver is holding a signal paddle for some reason.

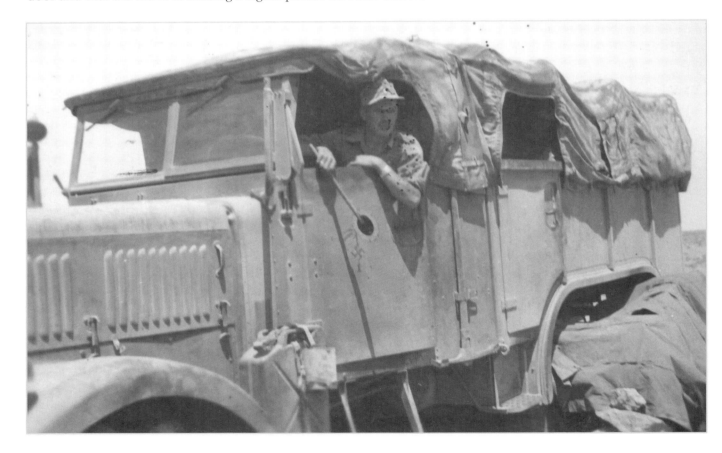

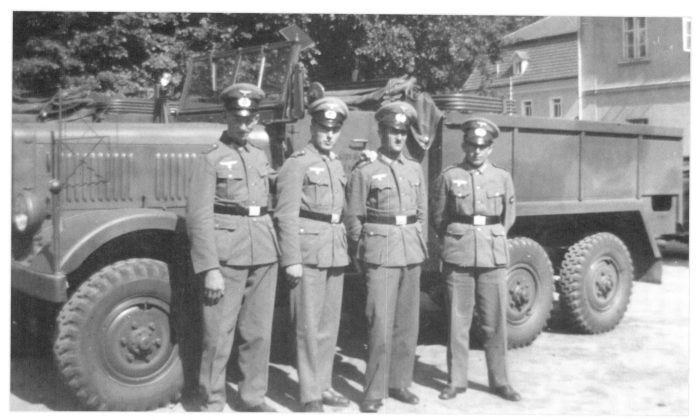

Above: A very clean and polished crew of an early variant of the *Einheits-Diesel* that is equally clean and polished. This crew are about to take part in a parade in Frankfurt, Germany, in the summer of 1938. Note the pre-war three-tone camouflage scheme and the very early style door to the rear tool locker, located below the very rear of the cargo bed and the back of the mudguard.

Below: This is a very late war photograph of one of the few surviving *Einheits-Diesel*s that lasted in service throughout the war until 1945. Unfortunately I have no more details as this page of the album that the photo came from is very water damaged.

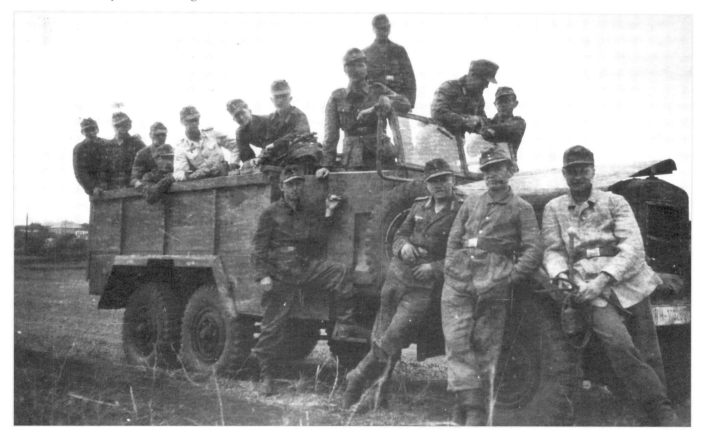

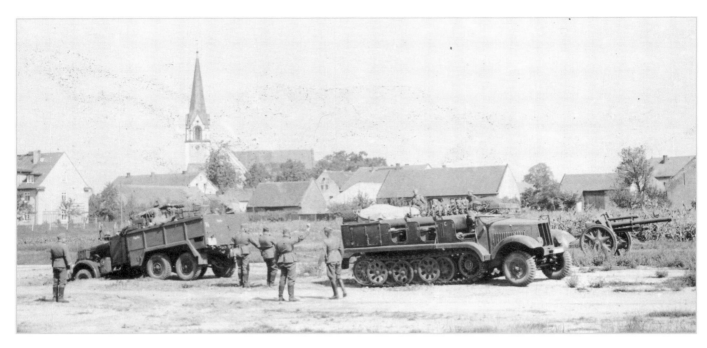

Above: This very enigmatic photograph is of a standard Kfz.77 *Einheits-Diesel* stuck in a drainage ditch just outside a Dutch town during the invasion of 1940. The truck is being recovered by an Sd.Kfz 6 halftrack from the same artillery unit; it has temporarily unhitched its towed 10,5 cm *leichte Feldhaubitze* 18 (10,5 cm le.FH 18) and will no doubt re-hitch the howitzer and continue with the advance as soon as the recovery is completed.
Below: Just behind this gent doing something with a lump of wood and a bucket, (washing a shirt, mixing porridge?) is a very nice front view of a freshly washed *Einheits-Diesel Funkkraftwagen* Kfz. 62 Meteorological Truck. Note the unit badge on the front left mudguard.

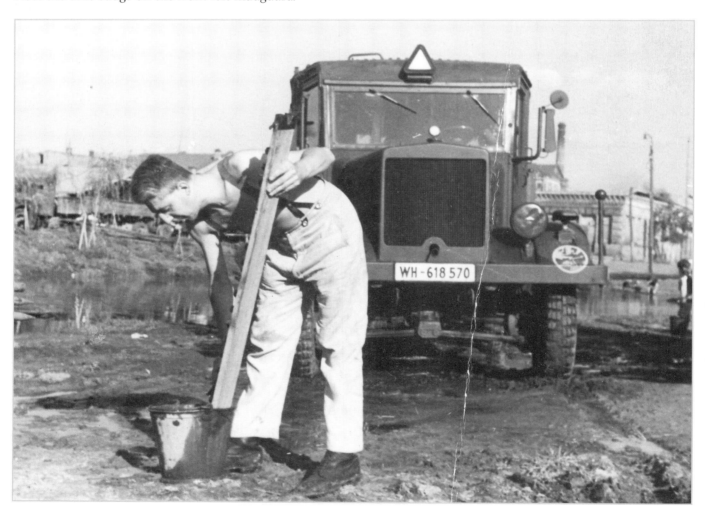

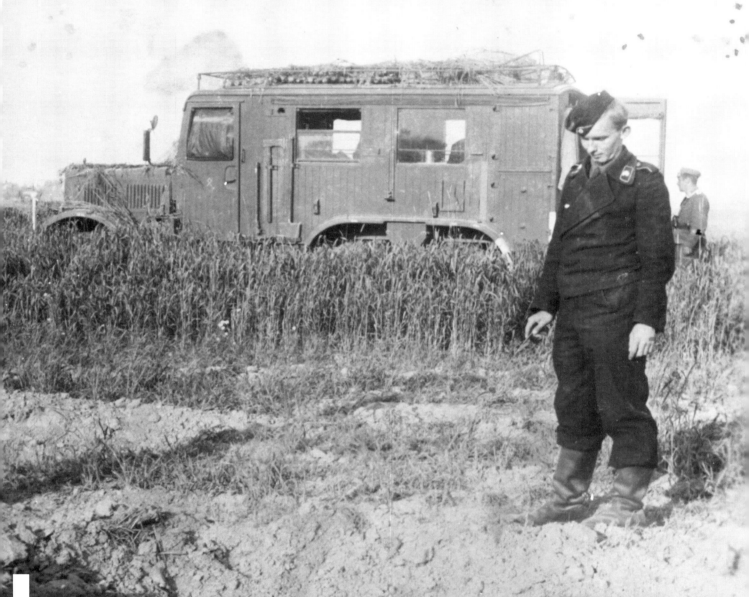

Here we have an *Einheits-Diesel Leichter Funkkraftwagen* Kfz. 302 (Light Command Radio Truck) belonging to the SS *Das Reich* Panzer Division, parked in a wheat field in the Ukraine in August 1941. Note the fine study of an SS Panzer trooper in the foreground with his distinctive two-piece black panzer uniform.

CLOSED BOX BODY VERSIONS

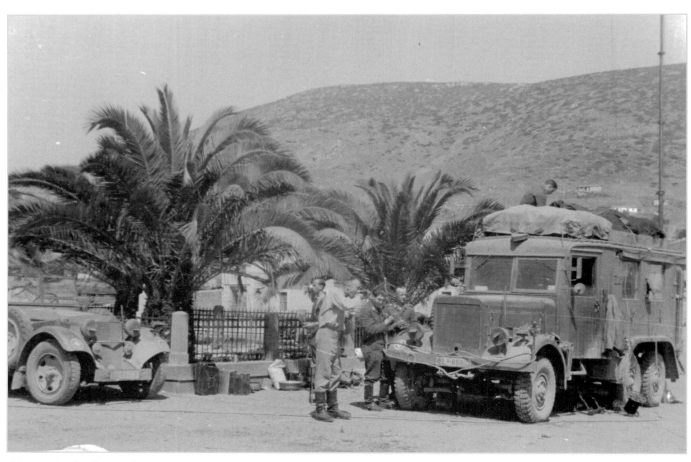

Above: Parked outside a cemetery in southern Greece, in this photograph are an Adler staff car and an *Einheits-Diesel Funkmast Kraftwagen Kfz. 68* Antenna Mast Truck. The crew are having a coffee break and seem to be in a relaxed mood. Note the extended antenna mast at the rear of the truck.

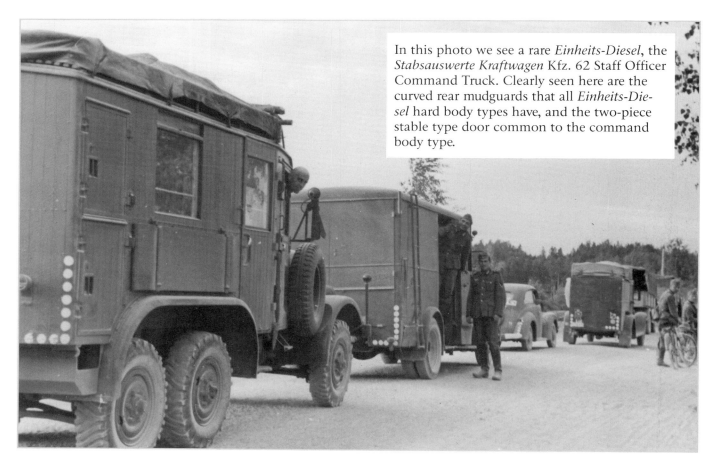

In this photo we see a rare *Einheits-Diesel*, the *Stabsauswerte Kraftwagen* Kfz. 62 Staff Officer Command Truck. Clearly seen here are the curved rear mudguards that all *Einheits-Diesel* hard body types have, and the two-piece stable type door common to the command body type.

Above: Only a taste of what was to come, here we see an *Einheits-Diesel Fernsprechbetriebs Kraftwagen* Kfz. 61 Telephone Exchange Truck struggling through the autumn mud in central Russia. To aid with its crossing the mud, the crew have disembarked and are watching the proceedings from the side of the mud road.

Below: This photograph illustrates an excellent example of a well-placed unit. This *Einheits-Diesel* Kfz. 61 Radio Operations Truck is parked up at the base of a hill with cover provided by trees. The vehicle has its aerial raised and is in full operating condition, however the crew are relaxing – one reading a paper, one on seated lookout and the other appears to be cooking on some kind of field stove.

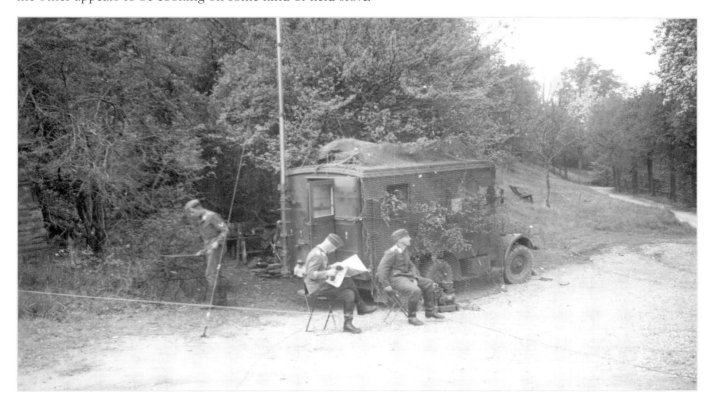

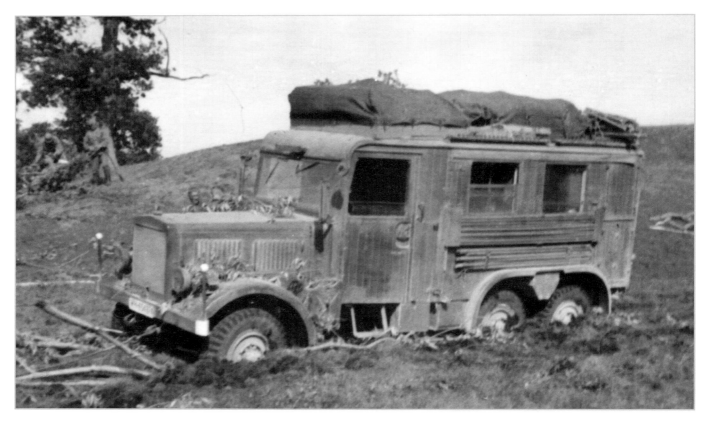

Above: In this photograph we have a *Einheits-Diesel* Kfz. 61 that has become stuck in the soft ground at the base of this small hill. In the absence of any suitable towing vehicle the crew are gathering timber to place under the wheels, in an attempt to free the truck from the mud.

Below: A very nice photograph of a typical German convoy of the early war years, this convoy is on a road north of Brussels, Belgium. From the left of the photo in the front row we have an Sd.Kfz. 10, a Horch Kfz. 15 command car, a Kublewagen and an *Einheits-Diesel* Kfz. 61. We can also see behind the front row a standard *Einheits-Diesel* Kfz. 77.

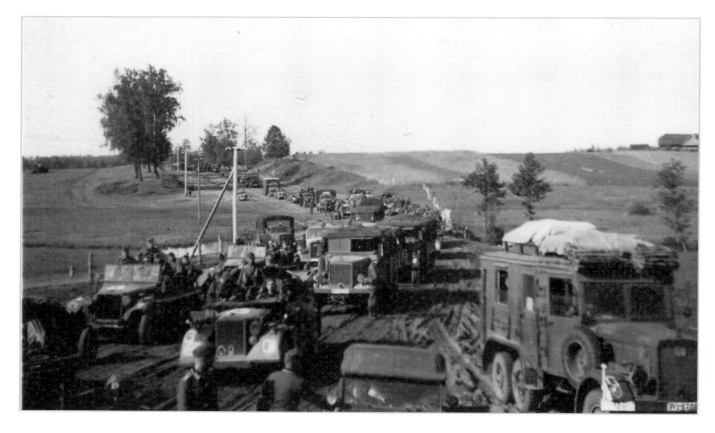

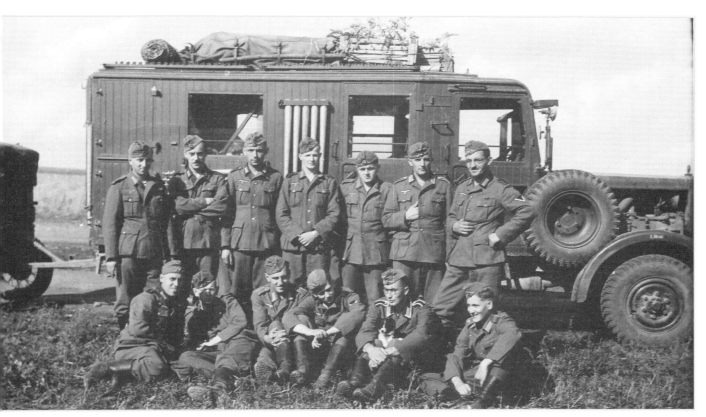

Above: This crew of communication engineers pose in front of one of their unit's *Einheits-Diesel Fernsprechbetriebs Kraftwagen* Kfz. 61 Telephone Exchange Trucks. Of note here is the missing side panel of the engine cover and proof of how useful the towing indicator was, as this vehicle is clearly towing a trailer full of the crew's effects but the tow indicator mounted above the windscreen at the top of the cab is still in the lowered position – thus indicating the truck is not towing anything.

Below: In this photograph we have a command convoy of associated radio trucks; the truck at the rear is an *Einheits-Diesel* Kfz. 302 Light Command Radio Truck however the other Radio Trucks in front of the *Einheits-Diesel* are all Mercedes LLG 3000 Kfz 72's Radio Communication Trucks, leading the convoy is a Ford Staff car.

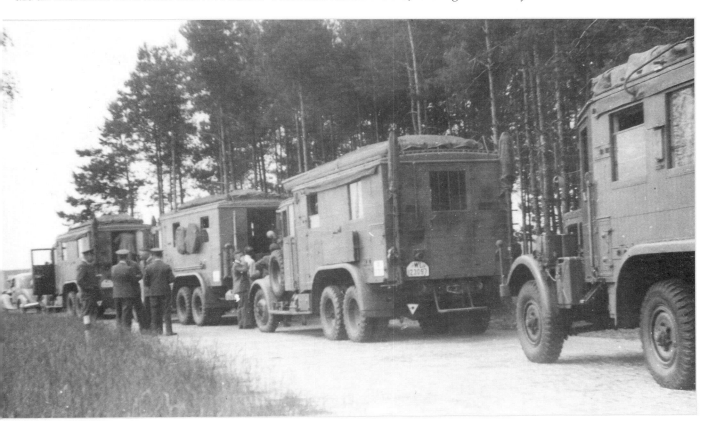

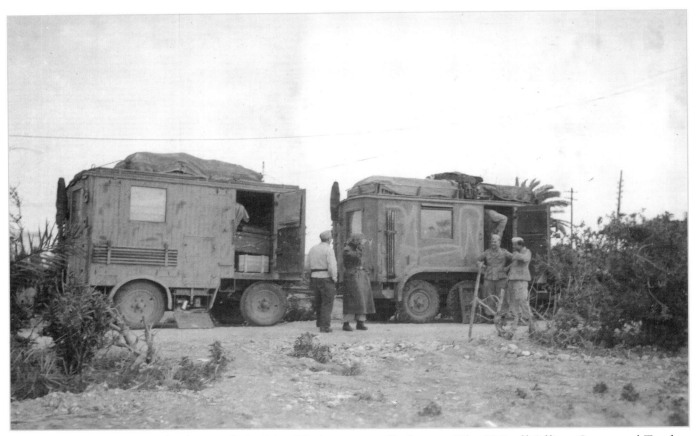

Above: A great photograph of an *Einheits-Diesel Stabsauswerte Kraftwagen* Kfz. 62 Staff Officer Command Truck and its associated command trailer. This photograph was taken in Libya in 1941 and gives us an interesting view of this rarely-seen combination.

Below: On 21st May 1941, close to the Yugoslavian town of Kotor (now in Montenegro), this *Einheits-Diesel* Kfz. 61 has slipped off the road and has put its right front wheel into a drainage ditch and damaged both its suspension and braking system. Evidently it took this crew 12 hours to fix this one and a further day to catch up with their unit.

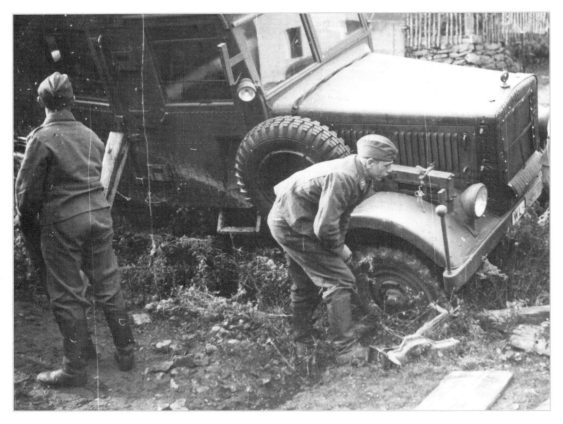

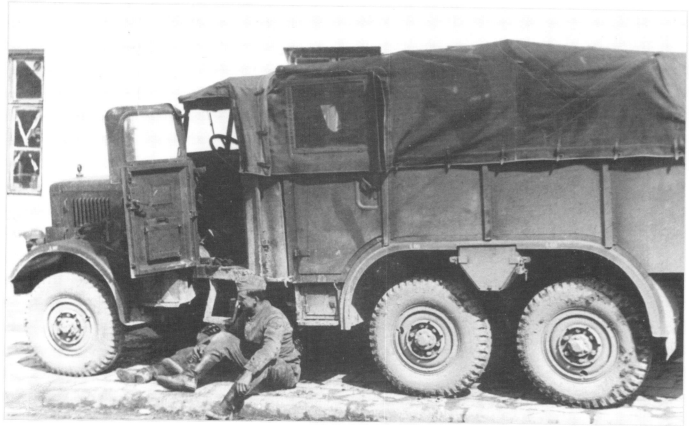

Above: This *Einheits-Diesel* Kfz. 63 *Berge und Abschlepp Kraftwagen* Recovery Truck is seen in Holland in 1940. Here the driver and his mate are doing a spot of maintenance to the clutch area of the drive train. Of note in this photo is the detail offered of the extra door of this variant's rear cargo bed.

Below: The crew of this *Einheits-Diesel* Kfz.61 Telephone Exchange Truck pose alongside their vehicle on a road somewhere in southern Russia in the summer of 1941. Whilst not clear in this photo in other of the same vehicle in my collection the trailer that it is towing is in fact an electric generator unit. Of note here is the clear view of the *Galande* tread pattern tires and the raised towing indicator located on top of the cab roof.

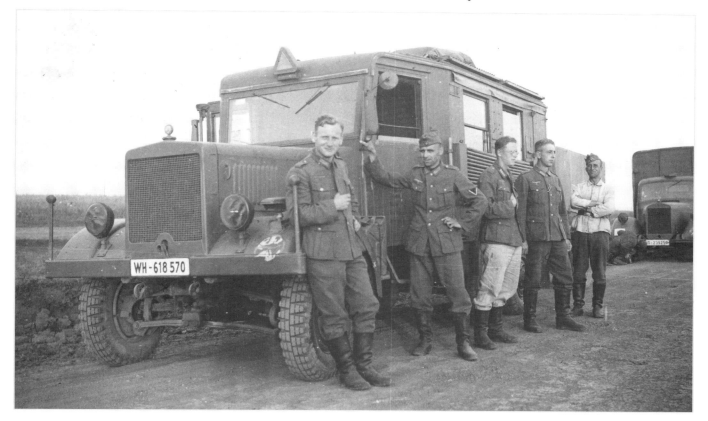

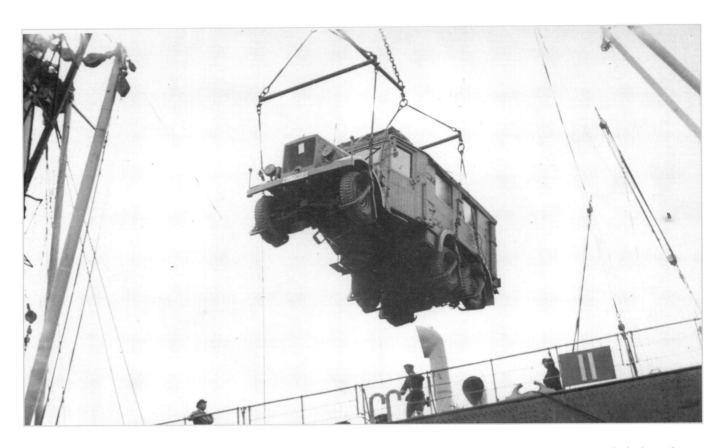

Two photos of an *Einheits-Diesel Funkkraftwagen* Kfz. 62 Meteorological Truck seen here being loaded aboard a ship bound for Tripoli, Libya, in 1941. The German army and *Luftwaffe* both used these types of vehicle and it was a regular sight to see tethered balloons flying high over the battle field, pausing at various heights for readings to be taken.

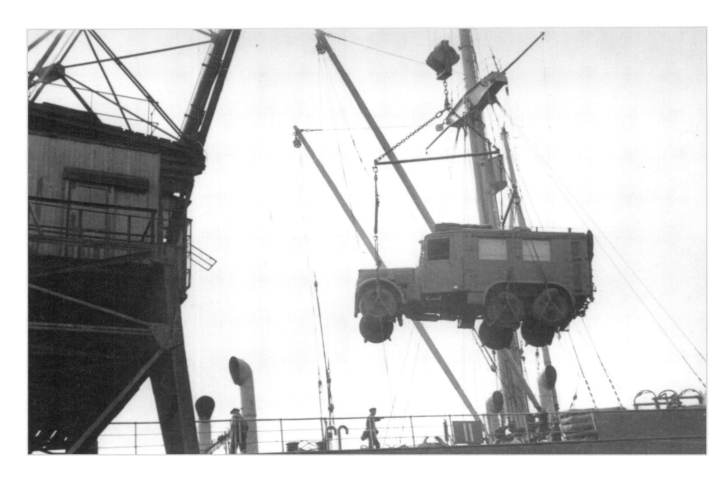

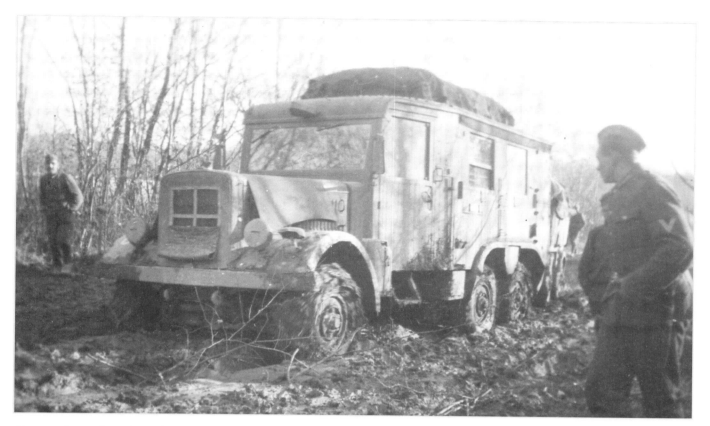

Above: A good quality photograph of an *Einheits-Diesel* Kfz. 61 making its way through the Russian mud in the autumn of 1941. Of interest here is the bad weather radiator shield and the flag tied over the engine cover for recognition from the air. The truck is towing an E3 standard German Army Trailer.

Below: This German column is led by an Kfz. 15 which being followed by an *Einheits-Diesel* Kfz. 61 *Verstarkerkraftwagen* Telephone Cable Amplifier Truck which in turn is being followed by an Opel *Blitz* 3-ton truck towing a trailer. This whole column is part of the advance into central Russia and belongs to General Guderian's Battle group. Note the extra unditching fascines stowed on top of the *Einheits-Diesel*.

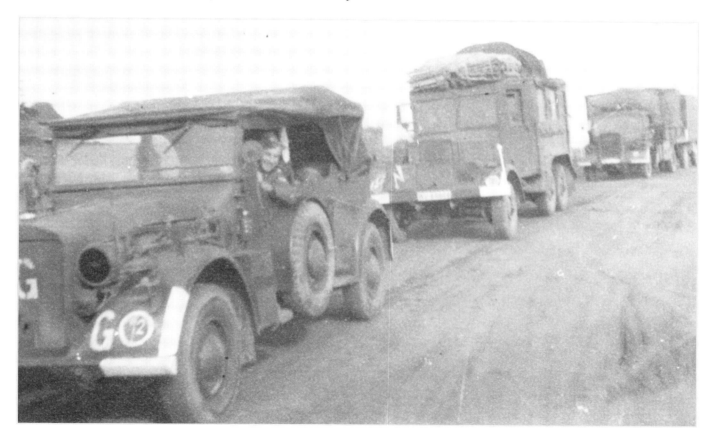

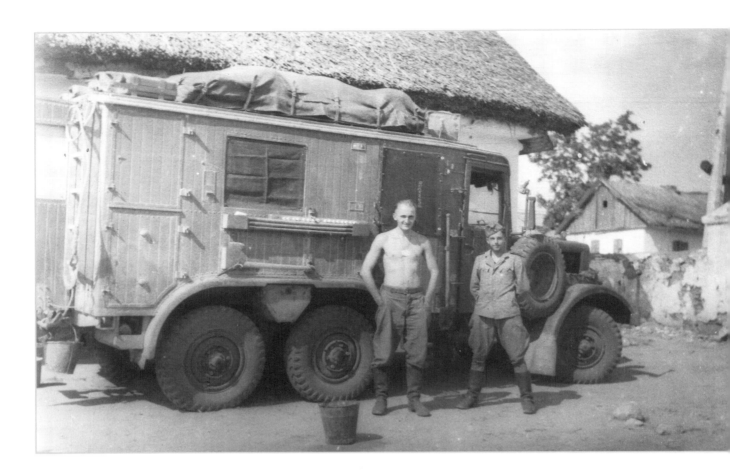

Above: The crew of this *Einheits-Diesel* Kfz. 61 strike a happy pose in southern Greece in the summer of 1942. Of note in this photo are the missing engine cover side panel and the steel bucket hung on the rear towing pintle.
Below: During the midwinter of 1941 to 1942 in Russia this *Einheits-Diesel Funkbetriebs Kraftwagen* Kfz. 61 Radio Operations Truck, that has its aerial in the stowed transport position, is passing the scene of an earlier skirmish that has left two Sd.Kfz. 251 Ausf As that belonged to General Guderian's Battle group destroyed and abandoned in the field.

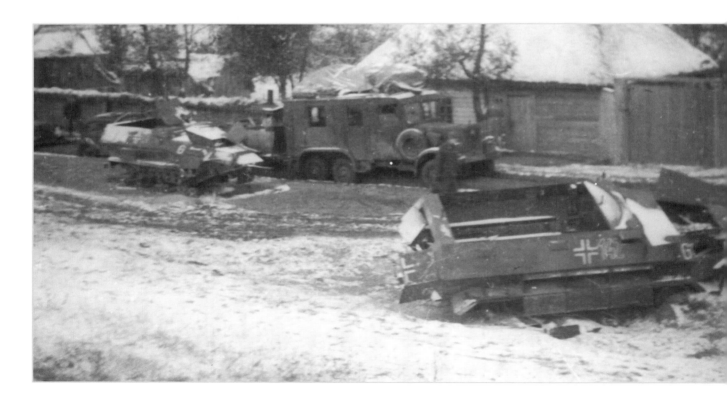

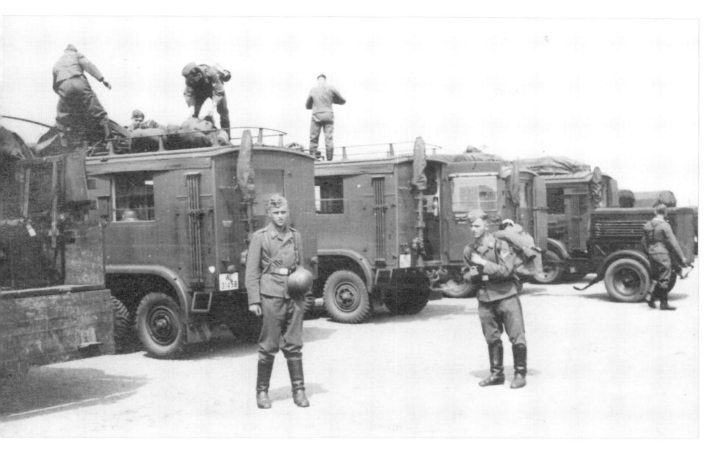

Above: Seen here during the preparations for operation Barbarossa, the invasion of Russia, is a communication unit equipped with *Einheits-Diesel Funkbetriebs Kraftwagen* Kfz. 61 Radio Operations Truck. The crews are stowing their personal kit and one soldier can be seen with his kit slung over his shoulder, another putting his on the roof rack of his vehicle. Also of interest in this photo is the electrical generator trailer.

Below: Here we have a standard *Einheits-Diesel* Kfz. 77 that has, due to need, been field converted to serve as a Kfz. 61 Radio Operations Truck. Note the timber plank field-made rear cabin and, to cope with the winter cold, the crew have made their own version of an insulated engine compartment by making a mat from bundles of reeds tied together. The heat from the activity in the rear cabin is causing a plume of steam to be given off by the evaporated moisture on the uninsulated roof.

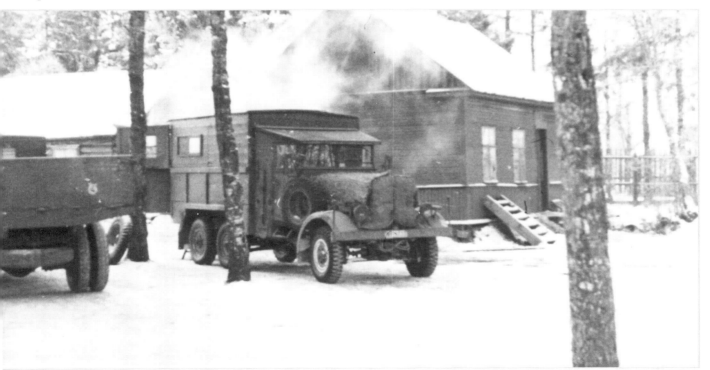

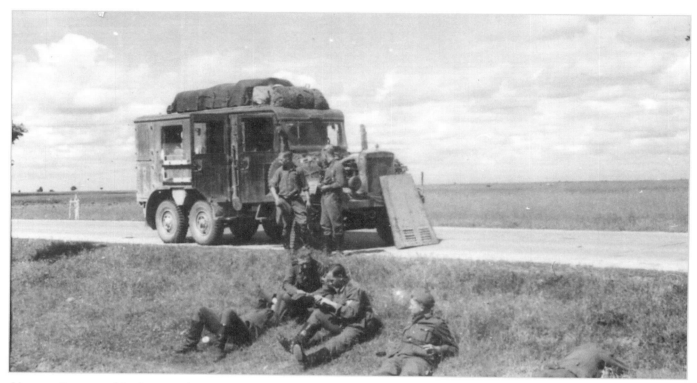

Above: On a road in Austria this *Einheits-Diesel* Kfz. 62 has broken down and it and the crew await a recover unit to attend the scene. Sadly the *Einheits-Diesel* in wartime service gained a bad reputation for poor reliability, but this was usually due to misuse or poor standards of preventative maintenance.

Below: Parked up outside a farmhouse in southern Russia we find this *Einheits-Diesel* Kfz. 61 Radio Operations Truck. As this unit operates some way behind the front lines it is a far more relaxed atmosphere, and we see here the crew are listening to gramophone records at the end of a summer's day.

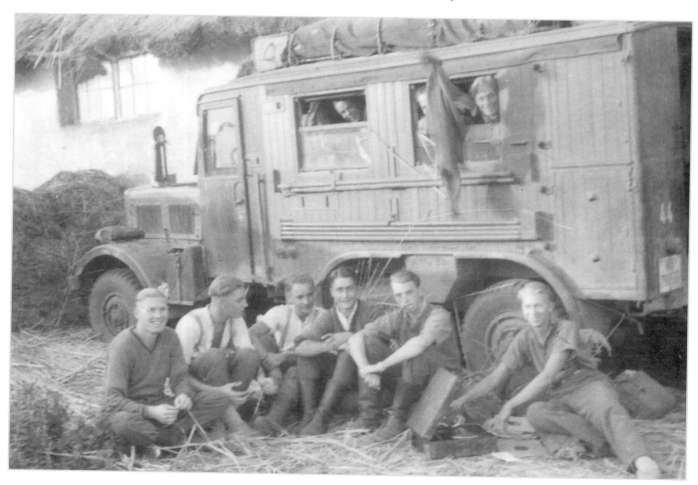

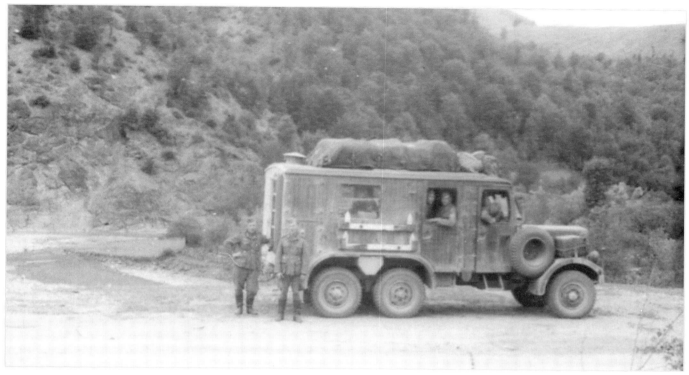

Above: Close to the border of Hungary but still in Yugoslavia, near to the town of Varazdin, we see an *Einheits-Diesel* Kfz. 62 whose crew are posing for a photo just prior to setting off on the day's march.
Below: This *Einheits-Diesel* Kfz. 61 Telephone Exchange Truck belongs to the Von Kleist Battle Group and is taking part in the invasion of Russia. The vehicle has one of its rear wheels removed and it is probably away to have a new tire fitted. Of interest to me here is that this photo bears witness to life in the field and shows how a vehicle has become home for this crew. Note the chess/checkers board that the crew member is packing away, just one of many such personal objects that a crew might carry with them to try and feel at home.

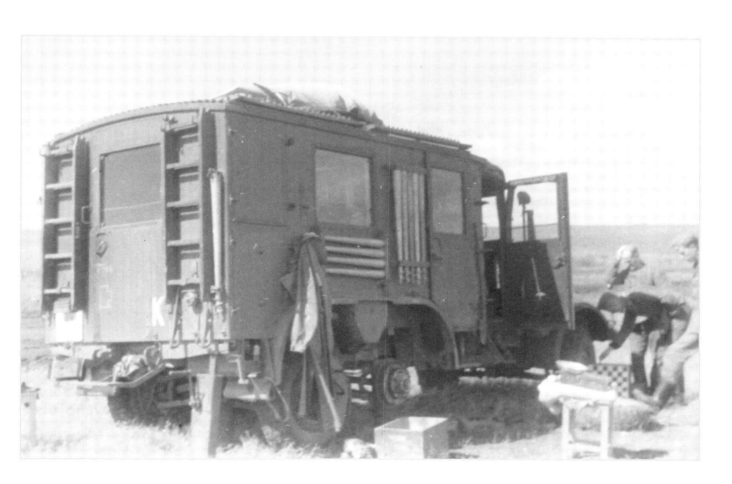

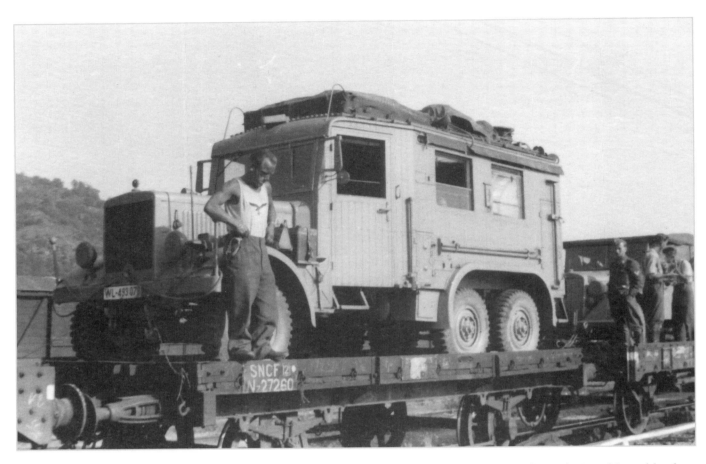

Above: This *Einheits-Diesel* Kfz. 62 Meteorological Truck belongs to a *Luftwaffe* unit that is being shipped back to Germany following the conclusion of the victory in Greece. Of note here is that whilst the rest of the train is made up of indigenous German rolling stock wagons, the flatbed wagon that this truck is on has been commandeered from the French rail network SNCF. During wartime rolling stock was mixed up all over the European rail network.

Right: An atmospheric photograph of an *Einheits-Diesel* Kfz. 61 that has slid off the road and has started down an embankment. The crew, aided by some Panzer crew members, are about to attempt its recovery.

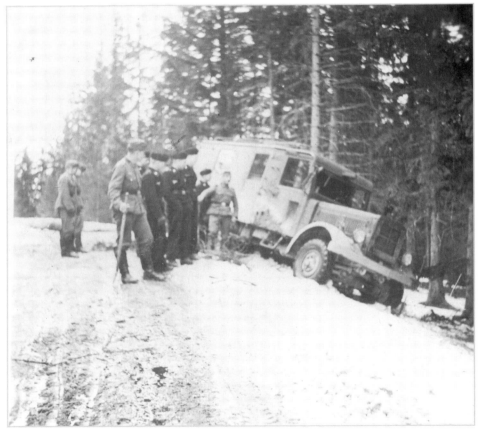

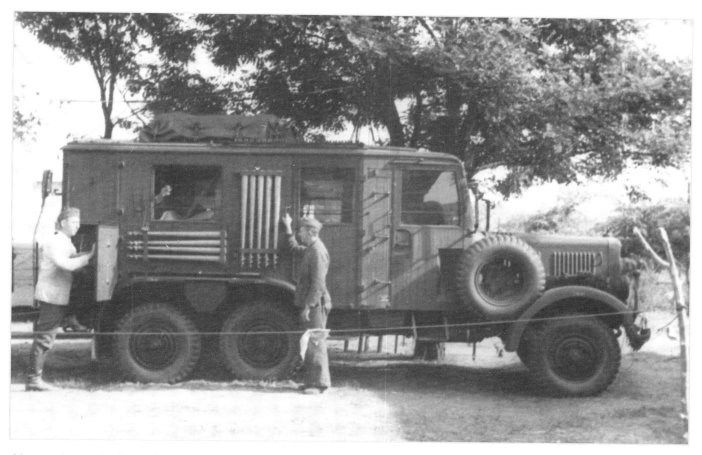

Above: A very high quality photograph of an *Einheits-Diesel* Kfz. 61 Telephone Exchange Truck that appears to be in excellent order, seen here parked next to a road in northern France in 1940

Here we see an *Einheits-Diesel* Kfz. 61 that is towing an Adler heavy field car over an area of undulating rough and muddy terrain in central Russia in the late summer of 1941. It was just such use of the *Einheits-Diesel* that led to their unreliability, as although their six wheel drive off-road capability was enough for their own specified task the trucks were just not up to the extra loads put on the drive train by such tasks.

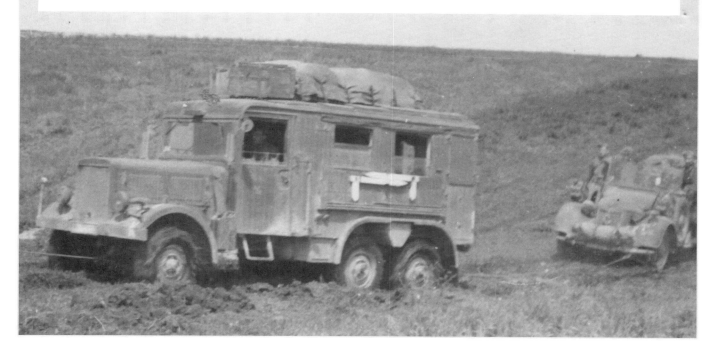

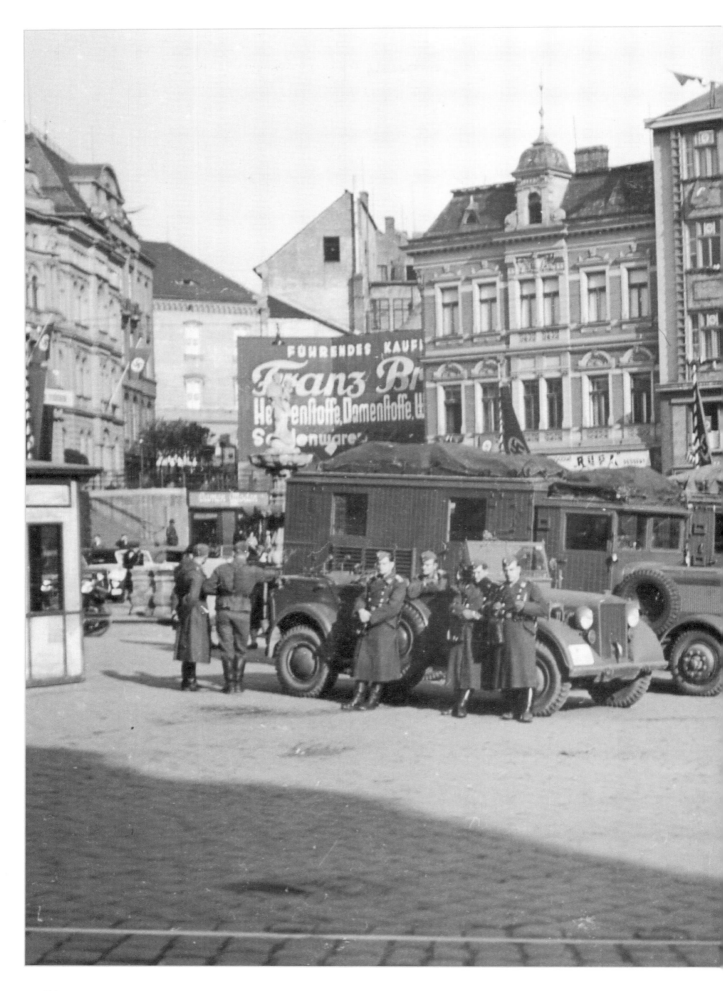

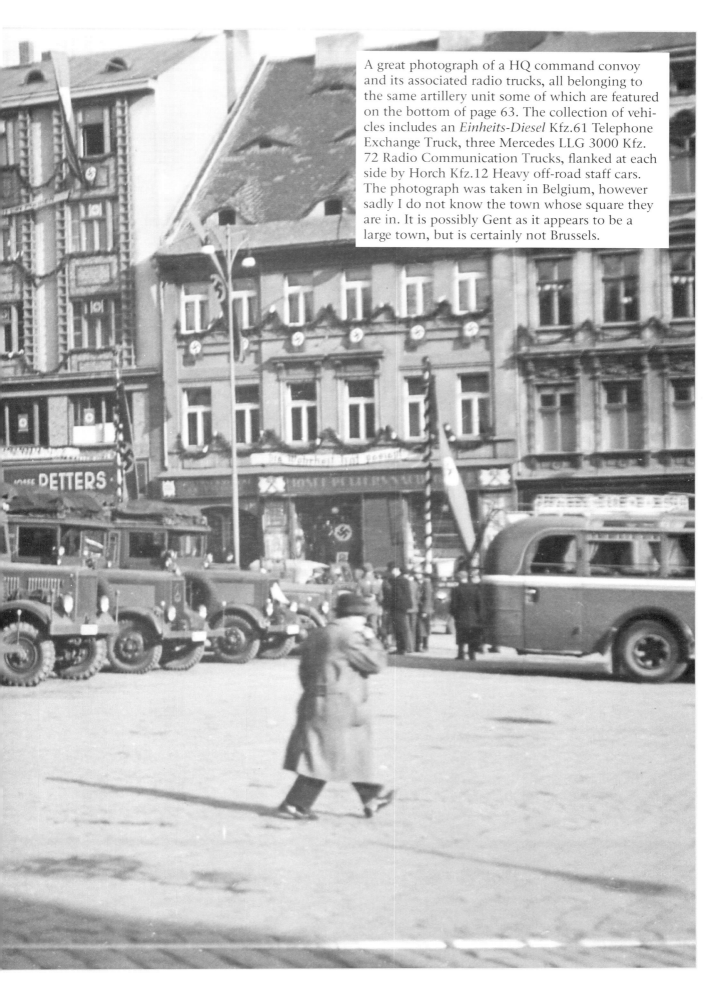

A great photograph of a HQ command convoy and its associated radio trucks, all belonging to the same artillery unit some of which are featured on the bottom of page 63. The collection of vehicles includes an *Einheits-Diesel* Kfz.61 Telephone Exchange Truck, three Mercedes LLG 3000 Kfz. 72 Radio Communication Trucks, flanked at each side by Horch Kfz.12 Heavy off-road staff cars. The photograph was taken in Belgium, however sadly I do not know the town whose square they are in. It is possibly Gent as it appears to be a large town, but is certainly not Brussels.

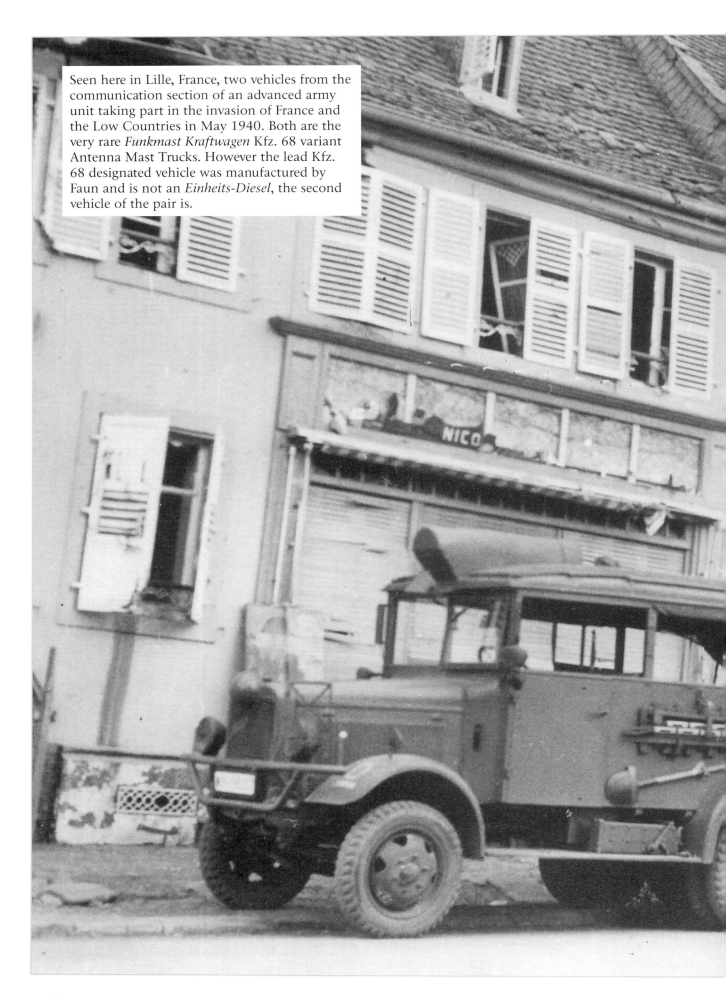

Seen here in Lille, France, two vehicles from the communication section of an advanced army unit taking part in the invasion of France and the Low Countries in May 1940. Both are the very rare *Funkmast Kraftwagen* Kfz. 68 variant Antenna Mast Trucks. However the lead Kfz. 68 designated vehicle was manufactured by Faun and is not an *Einheits-Diesel*, the second vehicle of the pair is.

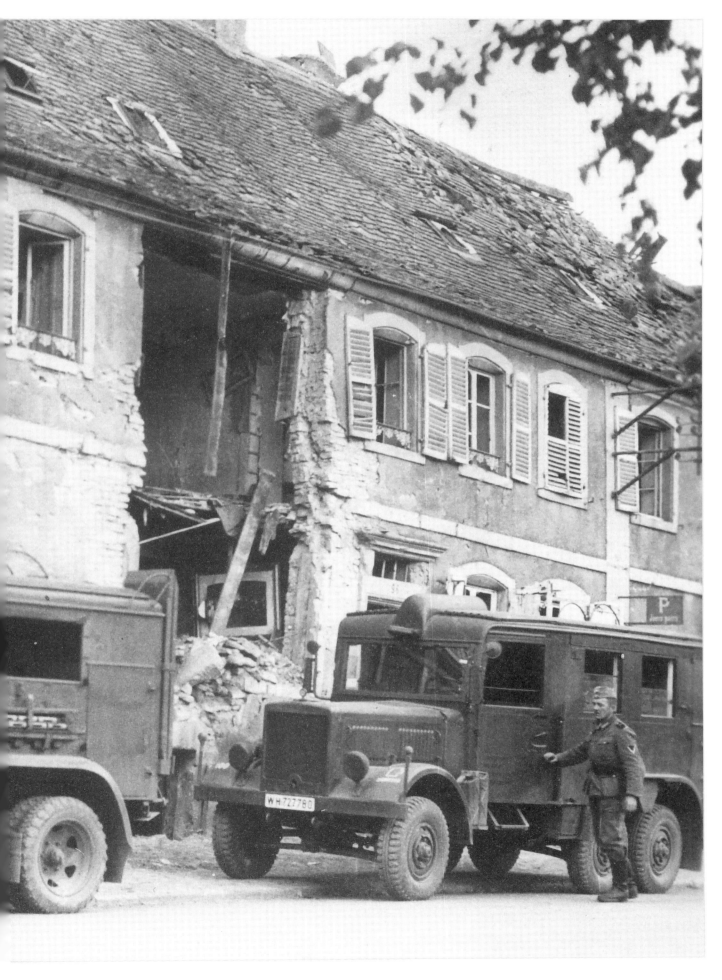

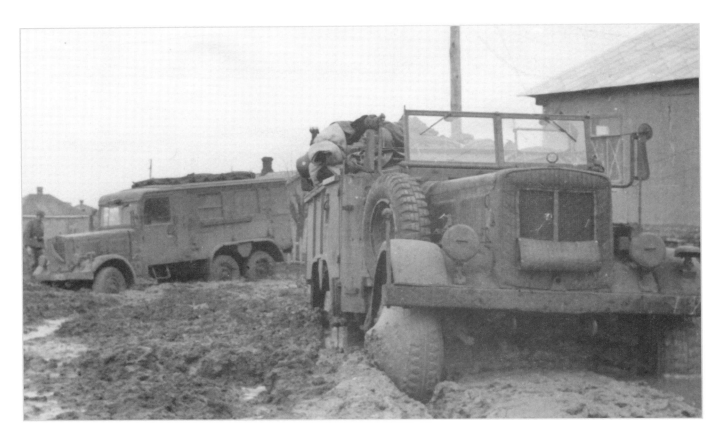

Above: Mud, mud and yet more mud, the story of a Russian autumn. In this photograph we see both a standard *Einheits-Diesel* Kfz. 77 and in the background an *Einheits-Diesel* Kfz. 61 Radio Operations Truck. Of note here is the way the mud builds up on the wheels and seems to stick to everything.

Below: After a close encounter with an exploding artillery shell, this *Einheits-Diesel* Kfz. 61 looks to be in a rather beaten up condition and has lost much of its exterior stowage. However the text in the album this photo came from states that this vehicle was repaired and back in service in only three days.

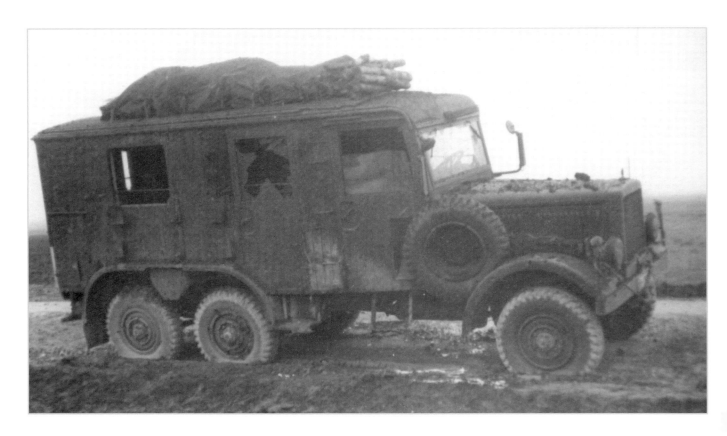

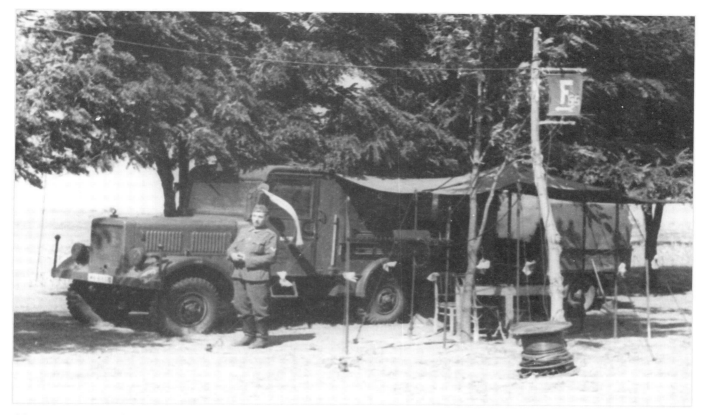

Above: Set up under the cover of a small group of trees we see here an *Einheits-Diesel Fernsprechbetriebs Kraftwagen* Kfz. 61 Telephone Exchange Truck with the side tilt extended and a workstation set up under it. Note the unit identification sign on the tree trunk and the roll of telephone cable at its base.

Below: Seen here we have the same truck and trailer as pictured above, it is an *Einheits-Diesel* Kfz. 61 Telephone Exchange Truck, however in this photograph it is shown from the other side and whilst still parked under some trees for cover the location is different and in the background here is a Russian orthodox high church, sadly I don't know the location.

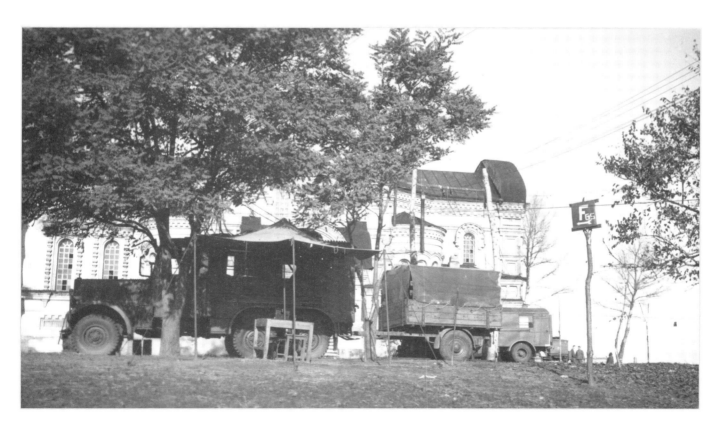

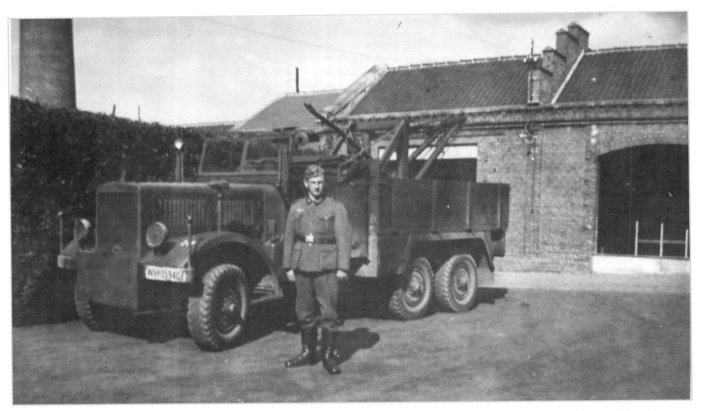

Above: Based on the rarer wooden rear cargo bedded version of the standard *Einheits-Diesel* Kfz. 77, this photo of a Recovery Truck was taken in the occupied French barracks in the city of Rouen in the summer of 1942. Note the twin boom crane mounted in the rear cargo bed.

Below: This standard *Einheits-Diesel* Kfz. 77 Recovery Truck is seen driving through a Russian village in the summer of 1941. Of note on this variant of the *Einheits-Diesel* is the Notek light mounted on a pole, itself mounted on the vehicle's left-hand fender and the steel plate mounted to the forward-most chassis cross member which served as protection to the front of the truck whilst it pushed other objects or vehicles.

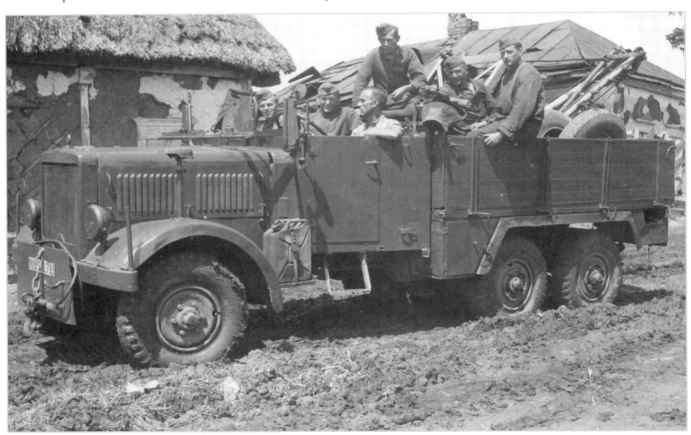